Treasures of

19TH- AND 20TH-CENTURY PAINTING

The Art Institute of Chicago

Treasures of
19TH- AND 20TH-CENTURY
PAINTING
The Art Institute of Chicago

Introduction by James N. Wood

A TINY FOLIO™
Abbeville Press Publishers
New York London Paris

Front cover: George Seurat, *A Sunday on La Grande Jatte—1884* (detail), 1884. See page 99.

Back cover: John Singer Sargent, *The Fountain, Villa Torlonia, Frascati*, 1907. See page 267.

Project Editor: Alice Gray Museum Editor: Adam Jolles
Designer: Patrick Seymour
Production Editor: Abigail Asher
Production Supervisor: Simone René

First Edition, second printing

Library of Congress Cataloging-in-Publication Data
Wood, James N.
 Treasures of 19th- and 20th-century painting, the Art Institute of Chicago / by James Wood.
 Includes index.
 ISBN 1-55859-603-8
 1. Painting, European—Catalogs. 2. Painting, Modern—19th century—Europe—Catalogs. 3. Painting, Modern—20th century—Europe—Catalogs. 4. Painting, American—Catalogs. 5. Painting, Modern—19th century—United States—Catalogs. 6. Painting—Modern—20th century—United States—Catalogs. 7. Painting—Illinois—Chicago—Catalogs. 8. Art Institute of Chicago—Catalogs. I Art Institute of Chicago. II. Title.
 ND457.W66 1993 93-22630
 759.05'074'77311—dc20 CIP

CONTENTS

INTRODUCTION

Perhaps no other collection in The Art Institute of Chicago is more renowned and beloved than the American and European paintings from the nineteenth and twentieth centuries. Some of our more notable works have become modern icons: both Grant Wood's *American Gothic* (page 280) and Edward Hopper's *Nighthawks* (page 293) are now emblems of American culture. Georges Seurat's *Sunday on La Grande Jatte—1884* (page 99) and Gustave Caillebotte's *Paris Street; Rainy Day* (page 69) have come to stand for the bold experimentation and achievements of the avant-garde in late nineteenth-century France. But what is so easily forgotten today is that the viewing public initially rejected this art, labeling it unrefined, banal, and unartistic. The astonishing story of these paintings is also that of the dedicated artists who weathered the heated diatribes delivered against their works and pursued a range of issues that were as varied and radical as the styles in which they painted. For the most part, however, they explored what it meant to create a record of their immediate world; what it meant to be, as the French poet and critic Charles Baudelaire so eloquently

articulated for them, not merely part of a great historical tradition, but rather active, sentient beings living in the present, and searching for meaning in their own time. Now, at the close of the twentieth century, these paintings are lauded as the revered relics of an earlier era, transformed by history from obscurity into icons of modernity. This folio is presented as both an introduction to this celebrated collection and a thoughtful survey of the styles, subjects, and themes of Western art of the last two centuries, from the crisp, linear classicism of Jean-Auguste-Dominique Ingres, through the innovative optical studies of Claude Monet and the Impressionists; from the colorful, lyrical abstractions of Vasily Kandinsky to the fractured monochromatic picture surfaces of Pablo Picasso and the Cubists; from the enigmatic compositions of Salvador Dali and the Surrealists to the media-appropriated, Pop-art portraits of Andy Warhol.

By the mid-nineteenth century, most museums were following the precedents established by the salons in Paris in acquiring contemporary works of art. Only those pieces that fit comfortably into the traditional classical mold—those that

depicted scenes from literature, mythology, or history—were considered worthy of collecting. Jean-Léon Gérôme's *Chariot Race* (page 68) is a fine example of what was most admired at the salons. But developing concurrently with nineteenth-century "retroclassicism" was a sub-culture of artists experimenting with alternative styles and subjects, venturing out of the academic studios into the streets and the countryside, and moving away from established subject matter in their art. The works of these radicals elicited cries of dismay from Parisian critics, and we might recognize the treatment these artists received as a harbinger of the difficulty twentieth-century innovators would face. From its birth, the history of modern art has been defined by a debate on the nature of art, quality, innovation, style, and form.

The Art Institute of Chicago's commitment to establishing a collection of modern paintings dates back to 1894, shortly after the founding of the museum, when Mrs. Henry Field donated in her husband's memory a substantial group of Barbizon paintings, including such works as Jules Breton's *Song of the Lark* (page 92), Jean-François Millet's *Peasants Bringing Home a Calf Born in the Fields* (page 39), and Théodore Rousseau's *Springtime* (page 32). The hazy, atmospheric renditions by these painters of the countryside north of Paris celebrated a rustic setting that was threatened by rapidly encroaching heavy industry.

The thick brushstrokes and textured surfaces of these softly toned paintings came out of the same formal tradition that had produced the exuberant Romantic works of Eugène Delacroix (page 24), and proved to be influential on such later artists as Jean-Baptiste-Camille Corot (page 49) and Vincent van Gogh (page 109).

The 1933 bequest of Mr. and Mrs. Martin A. Ryerson contained a number of exceptional French paintings, including works by Monet (page 57). Annie Swann Coburn (Mrs. Lewis Larned Coburn) frequently traveled abroad to visit the French salons and accumulated an impressive collection that contributed considerably to the museum's holdings. Among her more noteworthy gifts are a magnificent winter landscape by Camille Pissarro (page 46) and a stirring double portrait by Edgar Degas (page 65). Charles H. and Mary F. S. Worcester were other collectors who shared the Ryersons' and Mrs. Coburn's vision, donating fine mid-century paintings such as Frédéric Bazille's *Landscape at Chailly* (page 42).

These artists were among those who objected to the rigid structure and strict academic standards of the officially sanctioned salon. In 1874, Degas, Pissarro, Monet, and others organized an independent exhibition of their work. Their paintings, along with those of Paul Cézanne, Berthe Morisot, Pierre-Auguste Renoir, and Alfred Sisley were exhibited and were, for the most part, dismissed by the

9

reviewers and the public. Dubbed "the Impressionists" by an unsympathetic critic, the group shared an interest in loose brushwork, bright colors, and an emphasis on capturing the fleeting moments of everyday life. Contemporary subjects dominated their canvases, from the dapper flâneurs strutting down the boulevards of Paris (page 69) and the powerful, new steam engines criss-crossing the continent (page 70), to views of the French countryside, painted in natural light (page 81).

The museum's wealth of Impressionist art is regarded as one of the most comprehensive collections of its kind. Mr. and Mrs. Potter Palmer, renowned collectors and early turn-of-the-century supporters of French avant-garde art, donated, among other key works, pieces by Degas (page 112), Manet (page 40), Monet (page 96), Pissarro (page 86), Renoir (page 64), and Sisley (page 111). Mrs. Palmer, who became an unofficial dealer of Impressionist art, especially of the work of Monet, encouraged her friends nationwide to collect Impressionism, an effort that has contributed to the richness of many American museums in this area.

The last decade of the nineteenth century witnessed the rise of Post-Impressionism, as seen in the works of Cézanne, van Gogh, and Paul Gauguin. Unlike the Impressionists, these artists remained on the periphery of the art world, for the most part avoiding the salons, middle-class

social settings and, whether intentionally or not, the art markets as well. Van Gogh and Gauguin retreated to the countryside (Gauguin eventually fled to the South Pacific), isolating themselves from their peers. Along with Cézanne, these two contributed to innovative formal developments: the harmonic color schemes of Gauguin (page 128), the thickly textured brushstrokes of van Gogh (page 104), and the shifting, geometric planes of Cézanne (page 105) proved to be influential on many of the major avant-garde movements of the twentieth century. Gauguin and van Gogh also expanded the spiritual and emotional vocabulary of painting.

Works from this period came to the Art Institute from various sources, reflecting the expanding collecting tastes in the first quarter of the century. Frederic Clay Bartlett established the Helen Birch Bartlett Memorial Collection at the Art Institute in 1926, in memory of his second wife. The gift included what has become the museum's most famous image—Seurat's *Sunday on La Grande Jatte—1884* (page 99). This enormous canvas is acknowledged today as the manifesto painting of Divisionism, the pointillist method Seurat developed for recreating the luminosity of nature's tones as they blend and contrast in the viewer's eye. Seurat's masterpiece clearly depicts Impressionist subject matter—bourgeois leisure activity—but imbues it with a sense of abstraction

and mystery that is entirely new. The myriad patterns of tiny dots of paint covering the canvas recall the dappled brushwork of Monet and Pissarro, but seem much more deliberate and formalized.

The museum's devotion to American art dates back to the end of the last century, when, in 1888, it began sponsoring an annual American exhibition. These showcases served to promote the growth of American art, providing much-needed exposure to artists from around the country. In fact, many paintings now in the collection were selected from these early exhibitions. In 1910, the Friends of American Art began accumulating a compendium of works for the museum, and when this group disbanded in the 1940s, the Society for Contemporary American Art took on the work of their predecessors.

Today the Department of American Arts exhibits American paintings that date between the colonial era and 1900. Strengths in the nineteenth-century collection include the grandiose landscapes of Thomas Cole (page 138) and Frederic Edwin Church (page 140), which date from the first half of the century. Notable as well are the paintings and watercolors by Winslow Homer (pages 155, 158), which fully represent this artist's development and achievements. Still life arrangements by Raphaelle Peale (page 136) and Martin Johnson Heade (page 156) display the luminist tendencies of American painters working seventy

years apart. At the end of the century, a group of expatriate artists adapted a number of styles inspired by their encounters in Europe, including the innovations of the Impressionists and Post-Impressionists. Works by James McNeill Whistler and Mary Cassatt exhibit a variety of distinct European influences, particularly in Whistler's explorations of evocative color patterns (page 147) and Cassatt's cropped compositions (page 167). This late-century phenomenon is testimony to an ever-present, century-long conflict of interest in America—a burning desire to become independent from continental activity, and at the same time, an irrepressible need to be informed about and involved in whatever is happening on the other side of the Atlantic.

The city of Chicago received two strong doses of modern European art at the World's Columbian Exposition of 1893 and the Armory Show of 1913, which traveled to the Art Institute after its scandalous opening in New York City. A vast exhibition incorporating works by nearly all of the then-current European movements— Cubism, Expressionism, and Fauvism—the Armory Show introduced modern art to many Americans, viewers and artists alike. Although most of the innovative works on display were denounced by the critics and the general public, the show as a whole made an indelible impact on the course of American art.

Chicago attorney Arthur Jerome Eddy, arguably the most fervent supporter of modern European art in the Midwest, had been deeply impressed at the 1893 Fair with the exhibition of contemporary art, which inspired him to build a collection of his own. His enthusiasm led to his purchase of even more experimental works out of the Armory Show, works that rearranged traditional composition and perspective. The early modernists extended some of the pictorial innovations of their predecessors in the previous century, such as the emphasis on the picture surface, and the disjunction of forms in space, but for the most part, they insisted upon being seen as breaking with the past and establishing new modes of artistic investigation. In 1931, the museum received a large number of important modern pieces from Eddy, including examples of work by Kandinsky (pages 204, 212) and Gabriele Münter (page 207).

Robert Harshe's directorship is recognized as having provided the impetus to collect modern art. In 1921, the same year Harshe assumed the post of director, industrialist Joseph Winterbotham developed a unique fund for the museum, allowing the Art Institute to create a flexible collection of European masterpieces. A substantial endowment was established with the understanding that only thirty-five paintings in all were to be purchased. This number was reached in 1946, but Winterbotham had

specified that any work could be sold off or exchanged for a piece of equal or superior merit. Although the first purchases for this collection consisted primarily of late nineteenth-century pieces, the focus has since changed to include twentieth-century works by masters such as Marc Chagall (page 244), whose dreamlike images often refer to his experiences as a Russian Jew; Giorgio de Chirico (page 217), an Italian forerunner of Surrealism; the French Syncretist Robert Delaunay (page 209); and the Austrian Expressionist Oskar Kokoschka (page 195).

The 1926 gift of the Bartlett Collection, which, in addition to the Post-Impressionist works referred to above, also featured important paintings by Henri Matisse (page 225), Amedeo Modigliani (page 220), and Pablo Picasso (page 186), greatly broadened the museum's collection of modern paintings. The trustees accepted the gift with mixed feelings, sharing the public's continuing negative response to modern art. This gift occurred a full three years before the founding of The Museum of Modern Art in New York, and displays the keen insight and pioneering spirit of the museum's administration in accepting modern paintings when they were bound to provoke such contentious reactions.

In 1933 and 1934, the Art Institute mounted two major loan exhibitions recognizing one hundred years of collecting in America. The "Century of Progress

Expositions," as they were named, and the subsequent 46th Annual American Exhibition in 1935 featured new paintings by such innovative artists as George Bellows, Charles Demuth, Edward Hopper, and John Marin. Public preconceptions as to what American painting should look like were suddenly challenged by the haunting visions of urban life and the abstract compositions that were presented. The press lambasted the new styles in their reviews, the museum audience mocked the exhibitions, and several prominent Chicagoans retaliated by forming a reactionary group in 1936 called "Sanity in Art," a conservative backlash aimed at discouraging the new trends.

In 1943, Mr. Harshe's successor, Daniel Catton Rich, took a bold step forward and hired Katharine Kuh, an innovative Chicago dealer whose gallery had featured many of the most prominent contemporary European artists. With Rich's support, she directed the Gallery of Art Interpretation, a space she dedicated to addressing the sometimes alienating language of art. Mrs. Kuh's exhibits proved to be enlightening and educational, and won over large numbers of museum visitors. In 1954, she was named the museum's first Curator of Modern Painting and Sculpture; she and Rich were responsible for the acquisition of significant canvases by Willem de Kooning (page 299), Matisse (page 198), and Picasso (page 235), among others.

In 1961, Mrs. Kuh was replaced by A. James Speyer, around the same time that the administration officially inaugurated a separate department for the modern collection. Mr. Speyer was named Curator of Twentieth-Century Painting and Sculpture and asked to lead the fledgling department. In this period, the museum continued to acquire important mid-century European and American paintings, including Francis Bacon's *Head Surrounded by Sides of Beef* (page 251), Jean Dubuffet's *Genuflection of the Bishop* (page 254), Alberto Giacometti's *Isaku Yanaihara* (page 252), and René Magritte's *Time Transfixed* (page 246).

In the 1970s, Pop art came to the Art Institute in the form of such works as Roy Lichtenstein's *Brushstroke with Spatter* (page 313) and Andy Warhol's *Mao* (page 317). Evidence of the enormous impact of American consumer culture on contemporary art, the Pop movement celebrated everyday mass-produced objects, such as Brillo boxes and comic strips, and high-profile figures, such as Marilyn Monroe and Mao Tse-tung. In recent years, in keeping pace with new developments and practices, the department has actively sought outstanding pieces by such Europeans as German expressionist Georg Baselitz (page 256), English figurative artist Lucian Freud (page 258), and German conceptual painter Gerhard Richter (page 253), as well as several important works by American artists, including

Photo-Realist Richard Estes (page 318) and abstract painter Sean Scully (page 321).

In its over one-hundred-year history, the Art Institute has adhered closely to its original statement of purpose: "The funding and maintenance of schools of art and design, the formation and exhibition of collections of objects of art, and the cultivation and extension of the arts by any appropriate means." To this end the School of the Art Institute continues to be a major asset to both the museum and the city of Chicago. The school boasts numerous graduates who have led distinguished careers and are represented in the museum's collection of twentieth-century painting, among them Ivan Albright (page 288), Leon Golub (page 320), Georgia O'Keeffe (page 277), Ed Paschke (page 322), and Grant Wood (page 280). The school's existence is testimony to the institution's enthusiastic support of the principles of higher education and its commitment to the artists of tomorrow. A significant aspect of the Art Institute's mission is to ensure that both the hallways of the school and the galleries of the museum foster continuing dialogue about the art of the past, present, and future.

James N. Wood
Director and President

NINETEENTH-CENTURY EUROPEAN PAINTING

The Art Institute's collection of nineteenth-century European art provides a superb overview of French paintings from the period, as well as a selection of masterworks from England and from other continental countries. The first half of the century is richly represented by the feverish canvases of Eugène Delacroix (page 24) and the elegant portraits of Jean-Auguste-Dominique Ingres (page 23), among others. Gustave Courbet's muscular figures (page 29), Jean-François Millet's celebrations of the land and farmworkers (page 47), Jean-Baptiste-Camille Corot's idyllic Italianate landscapes (page 26), and Edouard Manet's boldly conceived and executed compositions (page 37) highlight the art of mid-century.

The latter part of the century saw the birth, struggles, and success of the Impressionists and Post-Impressionists in France. The European artworld was changed forever with the controversial works introduced in 1874 by the Impressionists. Shunning the academic classicism and heroic subject matter of their predecessors, these artists threw open the windows of their studios, intent on depicting everyday Parisian life in the dancehalls, theaters, outdoor cafés, and at the racetrack. The virtuosic renditions of

light-filled landscapes, still lifes, and portraits by Impressionists such as Claude Monet (page 51), Berthe Morisot (page 63), Pierre-Auguste Renoir (page 56), Camille Pissarro (page 83), and Alfred Sisley (page 59), and the depictions of modern urban life by Gustave Caillebotte (page 69), Edgar Degas (page 72), and Henri de Toulouse-Lautrec (page 120) swung the history of Western art toward a focus on the present and an emphasis on the formal qualities of light, color, and composition. The next generation, the Post-Impressionists, pursued very distinct interests, further elaborating upon the formal developments of the Impressionists. They include the shimmering Divisionist technique of Georges Seurat (page 99), the bold color schemes and passionate brushwork of Vincent van Gogh (page 108), the deeply symbolic compositions of Paul Gauguin (page 119), and the formal investigations of Paul Cézanne (page 125).

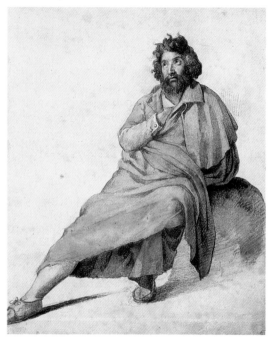

THÉODORE GÉRICAULT (1791–1824)
An Italian Mountain Peasant, c. 1816/17. Watercolor over chalk
on paper, 10⅛ x 8⅜ in. (25.7 x 21.3 cm)

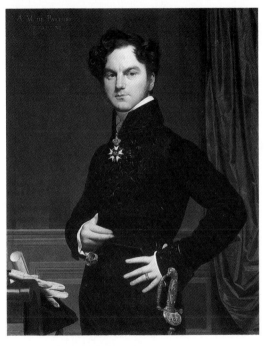

JEAN-AUGUSTE-DOMINIQUE INGRES (1780–1867)
Amédée-David, Marquis de Pastoret, c. 1823
Oil on canvas, 40½ x 32¾ in. (102.9 x 83.3 cm)

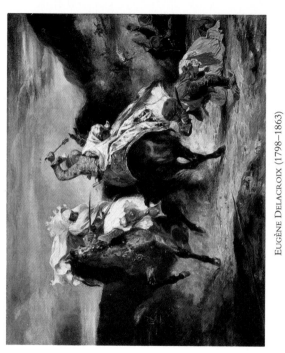

EUGÈNE DELACROIX (1798–1863)
Combat of the Giaour and Hassan, 1826
Oil on canvas, 23½ x 28⅞ in. (59.7 x 73.3 cm)

EUGÈNE DELACROIX (1798–1863)
Crouching Woman, Study for *The Death of Sardanapalus*, 1827/28. Pastel with chalk over wash on paper, 9¾ x 12⅜ in. (24.8 x 31.4 cm)

JEAN-BAPTISTE-CAMILLE COROT (1796–1875)
View of Genoa, 1834. Oil on paper mounted
on canvas, 11⅝ x 16⅜ in. (29.5 x 41.6 cm)

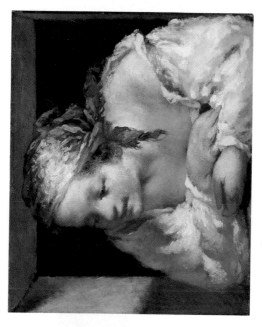

JEAN-FRANÇOIS MILLET (1814–1875)
Young Woman, c. 1844/45
Oil on canvas, 20½ x 24½ in. (52.1 x 62.2 cm)

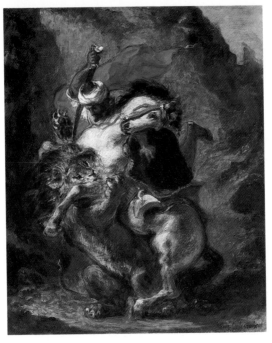

EUGÈNE DELACROIX (1798–1863)
Arab Horseman Attacked by a Lion, c. 1849/50
Oil on panel, 18 x 14¾ in. (45.7 x 37.5 cm)

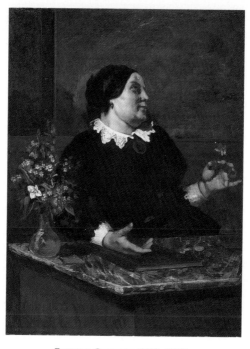

GUSTAVE COURBET (1819–1877)
La Mère Grégoire, 1855–59
Oil on canvas, 50¾ x 38⅜ in. (129 x 97.5 cm)

HONORÉ DAUMIER (1808–1879)
The Print Collector, 1857/63
Oil on panel, 16⅝ x 13 in. (42.2 x 33 cm)

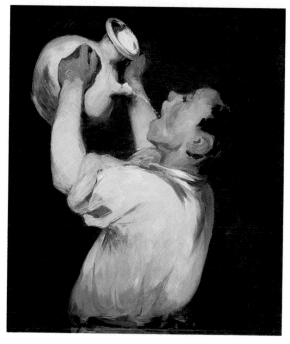

EDOUARD MANET (1832–1883)
Boy with Pitcher, c. 1862
Oil on canvas, 24⅜ x 21⅜ in. (61.9 x 54.3 cm)

THÉODORE ROUSSEAU (1812–1867)
Springtime, c. 1860
Oil on panel, 16⅞ x 22⅛ in. (42.9 x 56.2 cm)

EUGÈNE DELACROIX (1798–1863)
Lion Hunt, 1860/61
Oil on canvas, 30⅛ x 38¾ in. (76.5 x 98.4 cm)

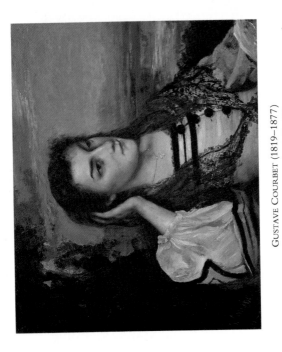

GUSTAVE COURBET (1819–1877)
Portrait of Gabrielle Borreau (The Dreamer), 1862. Oil on paper mounted on canvas, 25 x 30¼ in. (63.5 x 76.8 cm)

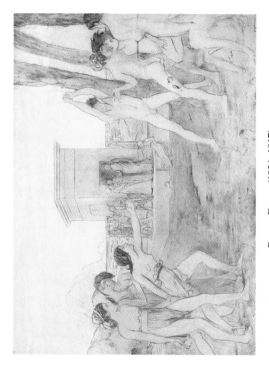

EDGAR DEGAS (1834–1917)
Young Spartans, c. 1860
Oil on canvas, 38¼ x 55⅝ in. (89.5 x 140 cm)

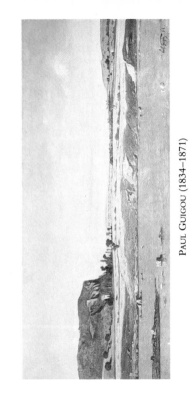

PAUL GUIGOU (1834–1871)
The Banks of the River Durance at Saint Paul, 1864
Oil on canvas, 24½ x 58¼ in. (62.2 x 148 cm)

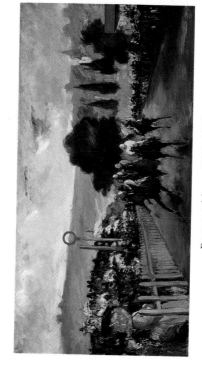

EDOUARD MANET (1832–1883)
Racetrack Near Paris, 1864
Oil on canvas, 17¼ x 33¼ in. (44.5 x 84.5 cm)

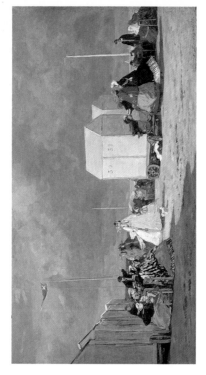

EUGÈNE BOUDIN (1824–1898)
Approaching Storm, 1864
Oil on panel, 14⅜ x 22¾ in. (36.5 x 57.8 cm)

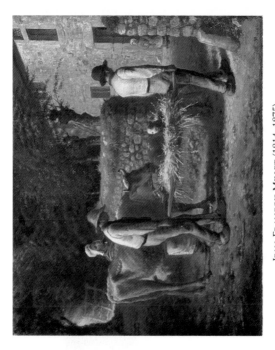

JEAN-FRANÇOIS MILLET (1814–1875)
Peasants Bringing Home a Calf Born in the Fields, 1864
Oil on canvas, 31⅛ x 39⅝ in. (81 x 100 cm)

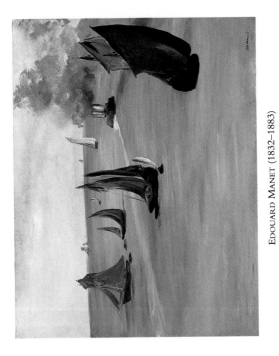

EDOUARD MANET (1832–1883)
Departure from Boulogne Harbor, 1864/65
Oil on canvas, 29 x 36½ in. (73.7 x 92.7 cm)

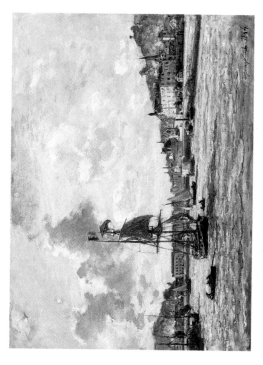

JOHANN BARTHOLD JONGKIND (1819–1891)
Entrance of the Port of Honfleur (Windy Day), 1864
Oil on canvas, 16⅝ x 22¼ in. (42.2 x 56.5 cm)

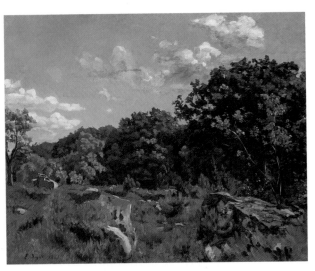

FRÉDÉRIC BAZILLE (1841–1870)
Landscape at Chailly, 1865
Oil on canvas, 31⅛ x 39½ in. (81 x 100.3 cm)

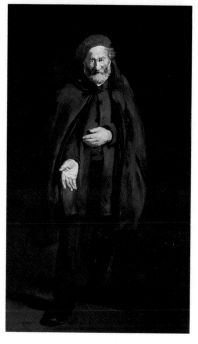

EDOUARD MANET (1832–1883)
Philosopher with Beret, 1865
Oil on canvas, 73⅞ x 43¼ in. (188 x 110 cm)

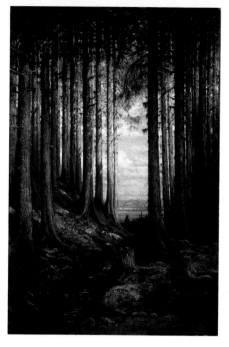

GUSTAVE DORÉ (1832–1883)
Alpine Scene, 1865
44 Oil on canvas, 77 x 51⅛ in. (196 x 130 cm)

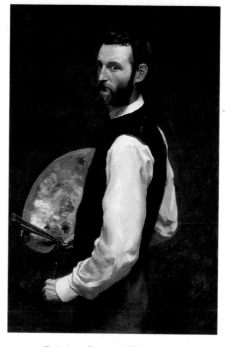

FRÉDÉRIC BAZILLE (1841–1870)
Self-Portrait, 1865/66
Oil on canvas, 42⅞ x 28⅜ in. (109 x 72.1 cm)

CAMILLE PISSARRO (1830–1903)
The Banks of the Marne in Winter, 1866
Oil on canvas, 36⅛ x 59½ in. (91.8 x 150.2 cm)

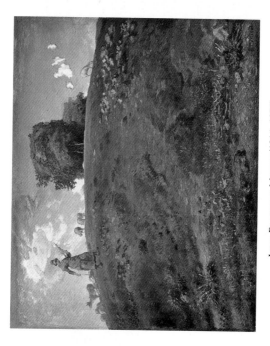

JEAN-FRANÇOIS MILLET (1814–1875)
In the Auvergne, 1866/69
Oil on canvas, 32⅛ x 39¼ in. (81.6 x 99.7 cm)

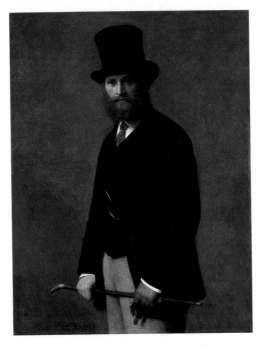

HENRI FANTIN-LATOUR (1836–1904)
Portrait of Edouard Manet, 1867
Oil on canvas, 46¼ x 35½ in. (117.5 x 90.2 cm)

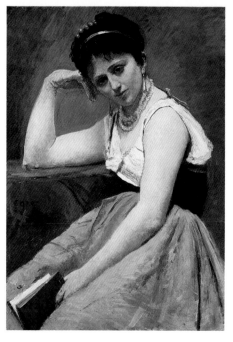

JEAN-BAPTISTE-CAMILLE COROT (1796–1875)
Interrupted Reading, c. 1870. Oil on canvas
on board, 36¼ x 25⅝ in. (92.1 x 65.1 cm)

CLAUDE MONET (1840–1926)
The Beach at Sainte-Adresse, 1867
Oil on canvas, 29⅞ x 40⅜ in. (75.9 x 102.5 cm)

CLAUDE MONET (1840–1926)
On the Seine at Bennecourt, 1868
Oil on canvas, 32⅛ x 39⅝ in. (81.6 x 101 cm)

GUSTAVE COURBET (1819–1877)
The Rock of Hautepierre, c. 1869
Oil on canvas, 31½ x 39½ in. (80 x 100 cm)

CAMILLE PISSARRO (1830–1903)
The Crystal Palace, 1871
Oil on canvas, 18⅝ x 28⅞ in. (47.3 x 73.3 cm)

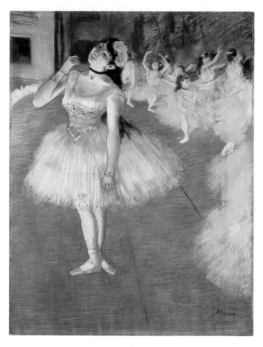

EDGAR DEGAS (1834–1917)
The Star, 1871/81
54 Pastel on paper, 28⅞ x 22⅝ in. (73.3 x 57.5 cm)

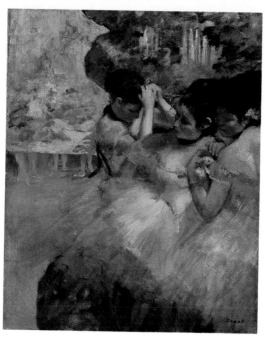

EDGAR DEGAS (1834–1917)
Dancers Preparing for the Ballet, c. 1872/76
Oil on canvas, 28⅞ x 23½ in. (73.3 x 59.7 cm)

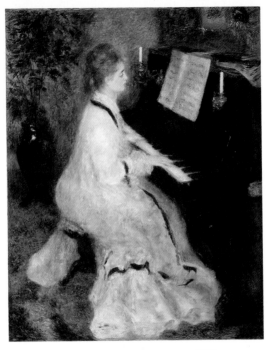

PIERRE-AUGUSTE RENOIR (1841–1919)
Lady at the Piano, 1875
Oil on canvas, 36⅜ x 29½ in. (93 x 74.9 cm)

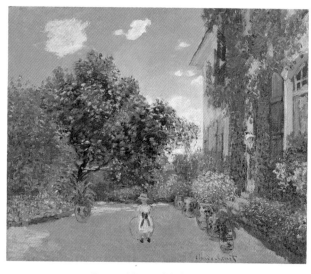

CLAUDE MONET (1840–1926)
Monet's House at Argenteuil, 1873
Oil on canvas, 23¾ x 28⅞ in. (60.3 x 73.7 cm)

HENRI FANTIN-LATOUR (1836–1904)
Still Life: Corner of a Table, 1873
Oil on canvas, 37⅞ x 49⅛ in. (96.2 x 125 cm)

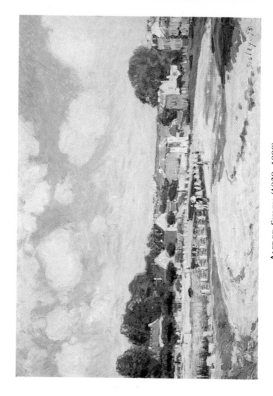

ALFRED SISLEY (1839–1899)
Watering Place at Marly, 1875
Oil on canvas, 15½ x 22⅛ in. (39.4 x 56.2 cm)

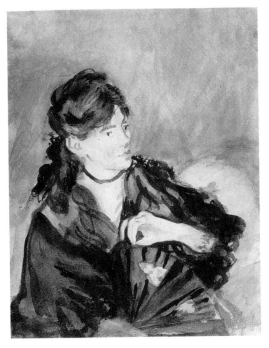

EDOUARD MANET (1832–1883)
Portrait of Berthe Morisot, c. 1873
Watercolor on paper, 8⅛ x 6½ in. (20.6 x 16.5 cm)

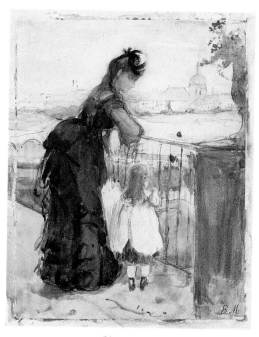

BERTHE MORISOT (1841–1895)
On the Balcony, c. 1873. Watercolor over pencil
on paper, 8⅛ x 6⅞ in. (20.6 x 17.5 cm)

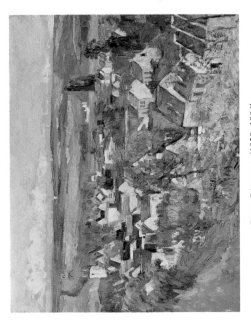

PAUL CÉZANNE (1839–1906)
Auvers, Panoramic View, 1873/75
Oil on canvas, 25⅝ x 32 in. (65.1 x 81.3 cm)

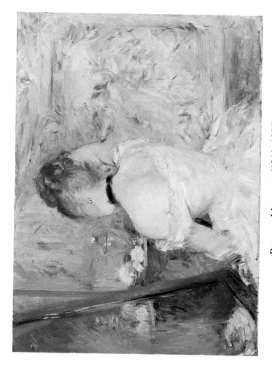

BERTHE MORISOT (1841–1895)
Woman at Her Toilet, c. 1875
Oil on canvas, 23¾ x 31⅝ in. (59.6 x 80.3 cm)

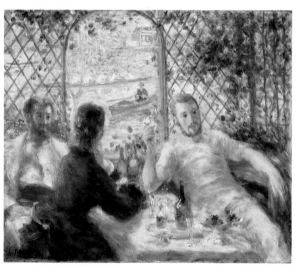

PIERRE-AUGUSTE RENOIR (1841–1919)
The Rowers' Lunch, 1875/76

64 Oil on canvas, 21¾ x 25⅞ in. (55.2 x 65.7 cm)

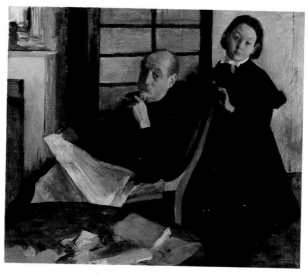

EDGAR DEGAS (1834–1917)
Uncle and Niece (Henri de Gas and His Niece Lucie), 1875/78
Oil on canvas, 39¼ x 47¼ in. (99.7 x 120 cm)

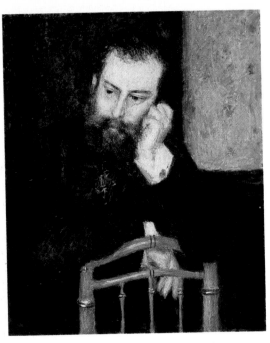

PIERRE-AUGUSTE RENOIR (1841–1919)
Alfred Sisley, c. 1875/76
Oil on canvas, 26⅛ x 21⅝ in. (66.4 x 54.9 cm)

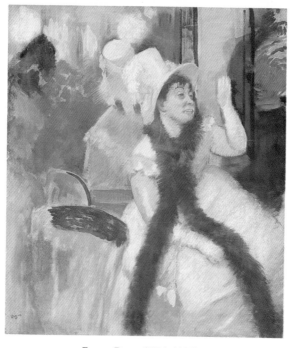

EDGAR DEGAS (1834–1917)
Portrait after a Costume Ball (Portrait of Mme. Dietz-Monnin), 1877/79
Oil and tempera on canvas, 33⅝ x 29½ in. (85.4 x 74.9 cm) 67

JEAN-LÉON GÉRÔME (1824–1904)
Chariot Race, 1876
Oil on panel, 34 x 61½ in. (86.4 x 156.2 cm)

GUSTAVE CAILLEBOTTE (1848–1894)
Paris Street; Rainy Day, 1876–77
Oil on canvas, 83½ x 108¾ in. (212 x 276 cm)

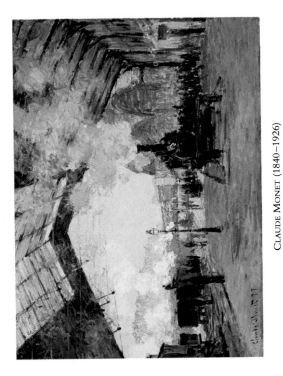

CLAUDE MONET (1840–1926)
Arrival of the Normandy Train, Saint Lazare Station, 1877
Oil on canvas, 23½ x 31½ in (59.7 x 80 cm)

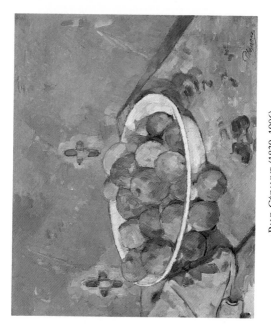

PAUL CÉZANNE (1839–1906)
Plate of Apples, c. 1877
Oil on canvas, 18 x 21½ in. (45.7 x 54.6 cm)

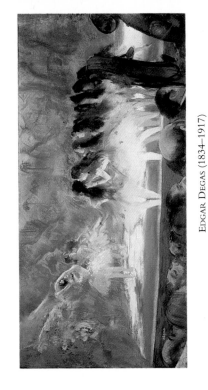

EDGAR DEGAS (1834–1917)

Ballet at the Paris Opéra, 1877/78. Pastel over monotype on paper, 13⅞ x 27¼ in. (35.2 x 70.5 cm)

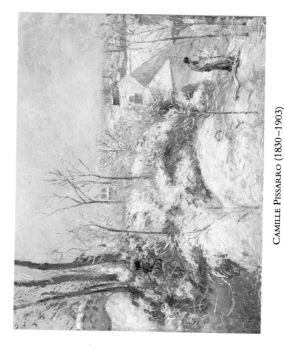

CAMILLE PISSARRO (1830–1903)
Rabbit Warren at Pontoise, Snow, 1879
Oil on canvas, 23⅜ x 28½ in. (59.4 x 72.4 cm)

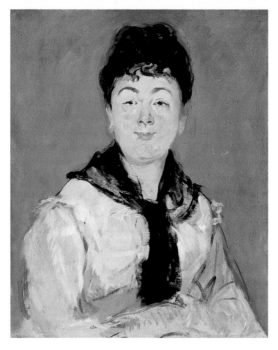

EDOUARD MANET (1832–1883)
Portrait of a Lady with Black Fichu, c. 1878
Oil on canvas, 24⅛ x 19⅞ in. (61 x 50.5 cm)

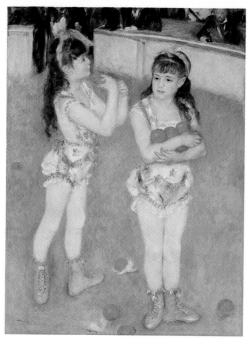

PIERRE-AUGUSTE RENOIR (1841–1919)
Jugglers at the Circus Fernando, 1878/79
Oil on canvas, 51¾ x 39⅛ in. (131 x 99.4 cm)

EDOUARD MANET (1832–1883)
Le Journal Illustré, c. 1878/79
Oil on canvas, 24⅛ x 19⅞ in. (61.3 x 50.5 cm)

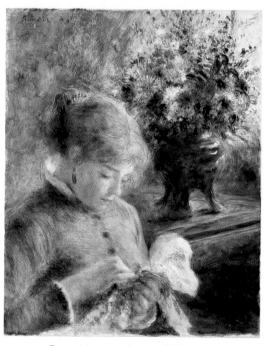

PIERRE-AUGUSTE RENOIR (1841–1919)
Lady Sewing, 1879
Oil on canvas, 24¼ x 19⅞ in. (61.6 x 50.5 cm)

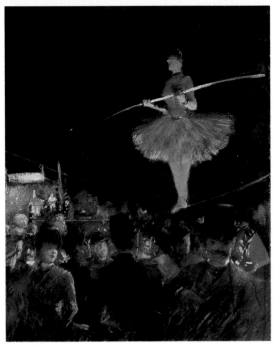

JEAN-LOUIS FORAIN (1852–1931)
The Tightrope Walker, 1880
Oil on canvas, 18⅛ x 15 in. (46 x 38.1 cm)

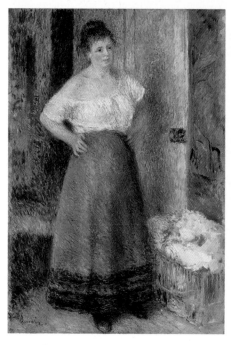

PIERRE-AUGUSTE RENOIR (1841–1919)
The Laundress, c. 1880
Oil on canvas, 32⅛ x 22¼ in. (80.6 x 56.5 cm)

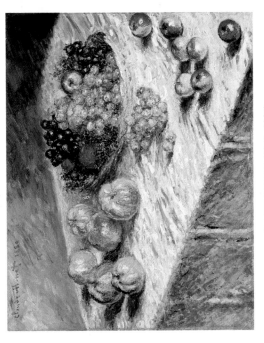

CLAUDE MONET (1840–1926)
Still Life: Apples and Grapes, 1880
Oil on canvas, 26⅛ x 32⅜ in. (66.4 x 82.2 cm)

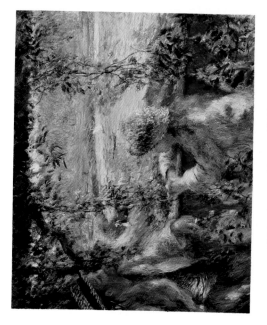

PIERRE-AUGUSTE RENOIR (1841–1919)
Near the Lake, c. 1880
Oil on canvas, 18¾ x 22⅜ in. (47.6 x 56.8 cm)

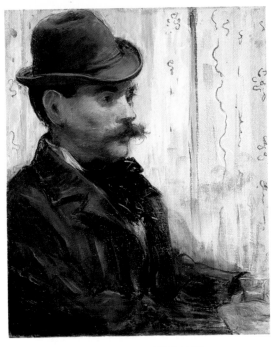

EDOUARD MANET (1832–1883)
Man with a Round Hat—Portrait of Alphonse Maureau, c. 1880
Pastel on canvas, 21½ x 17¾ in. (54.6 x 45 cm)

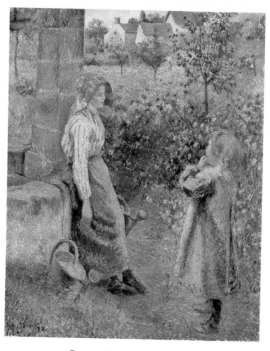

CAMILLE PISSARRO (1830–1903)
Woman and Child at the Well, 1882
Oil on canvas, 32⅛ x 26⅛ in. (81.6 x 66.4 cm)

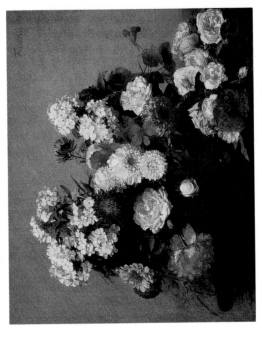

HENRI FANTIN-LATOUR (1836–1904)
Still Life with Flowers, 1881
Oil on canvas, 19 x 23½ in. (48.3 x 59.7 cm)

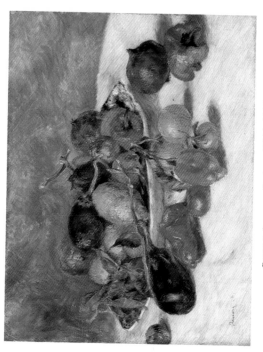

PIERRE-AUGUSTE RENOIR (1841–1919)
Fruits from the Midi, 1881
Oil on canvas, 19⅞ x 25¾ in. (101 x 65.4 cm)

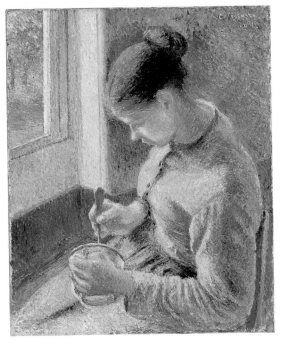

CAMILLE PISSARRO (1830–1903)
Café au Lait, 1881
Oil on canvas, 25 ¾ x 21 ⅝ in. (65.4 x 54.3 cm)

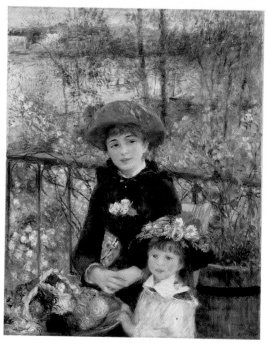

PIERRE-AUGUSTE RENOIR (1841–1919)
Two Sisters (On the Terrace), 1881
Oil on canvas, 39⅝ x 31⅞ in. (100.6 x 81 cm)

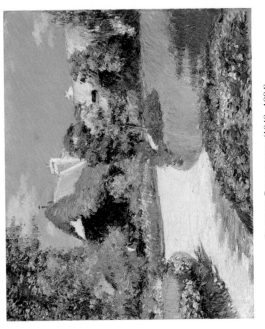

GUSTAVE CAILLEBOTTE (1848–1894)
Thatched Cottage at Trouville, 1882
Oil on canvas, 21½ x 23¾ in. (54.6 x 60.3 cm)

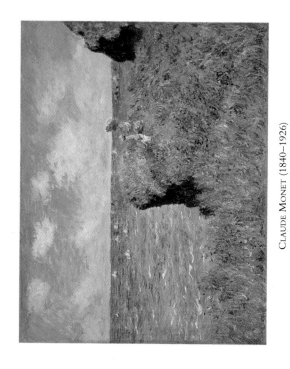

CLAUDE MONET (1840–1926)
Cliff Walk at Pourville, 1882
Oil on canvas, 26⅛ x 32⅛ in. (66.4 x 82.2 cm)

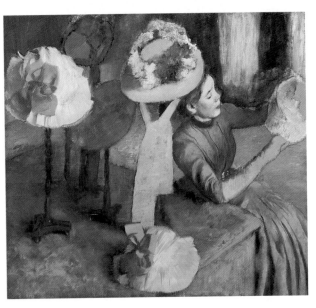

EDGAR DEGAS (1834–1917)
The Millinery Shop, 1882/86
Oil on canvas, 39⅜ x 43½ in. (100 x 109 cm)

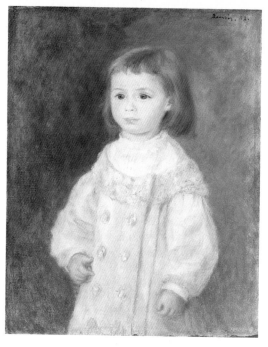

PIERRE-AUGUSTE RENOIR (1841–1919)
Lucie Bérard, Child in White, 1883
Oil on canvas, 24¼ x 19¾ in. (61.6 x 50.2 cm)

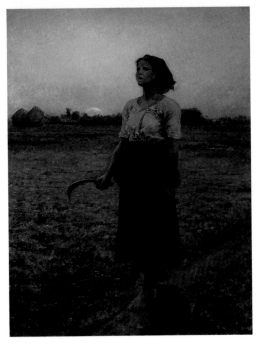

JULES BRETON (1827–1906)
The Song of the Lark, 1884
Oil on canvas, 43½ x 33¾ in. (111 x 85.7 cm)

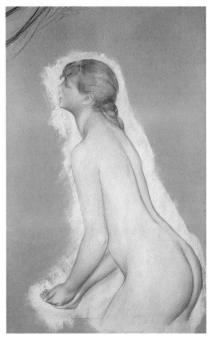

Pierre-Auguste Renoir (1841–1919)
Study for *The Bathers,* c. 1884/85. Chalk over graphite
on paper, 38¾ x 25¼ in. (97.3 x 64.1 cm)

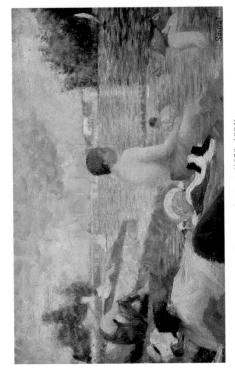

GEORGES SEURAT (1859–1891)
Final Study for *The Bathers at Asnières*, 1883
Oil on wood, 6¼ x 9⅞ in. (15.9 x 25.1 cm)

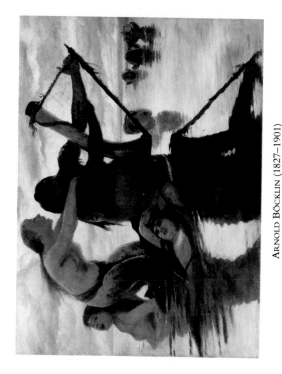

Arnold Böcklin (1827–1901)
In the Sea, 1883
Oil on panel, 34⅜ x 45¾ in. (87.3 x 114.8 cm)

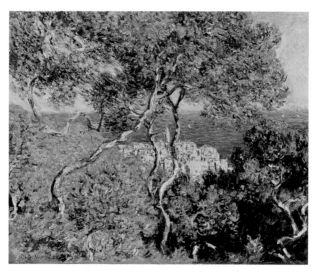

CLAUDE MONET (1840–1926)
Bordighera, 1884
Oil on canvas, 25 ½ x 32 in. (64.8 x 81.3 cm)

BERTHE MORISOT (1841–1895)
Forêt de Compiègne, 1885
Oil on canvas, 21⅜ x 25½ in. (54.3 x 64.8 cm)

GEORGES SEURAT (1859–1891)
Oil Sketch for *A Sunday on La Grande Jatte—1884*, 1884
Oil on panel, 6⅛ x 9⅝ in. (15.6 x 24.4 cm)

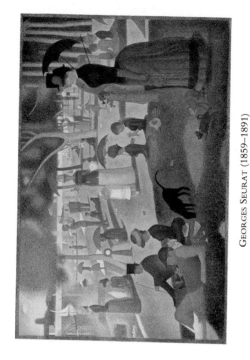

GEORGES SEURAT (1859–1891)
A Sunday on La Grande Jatte—1884, 1884–86
Oil on canvas, 81¾ x 21¼ in. (208 x 308 cm)

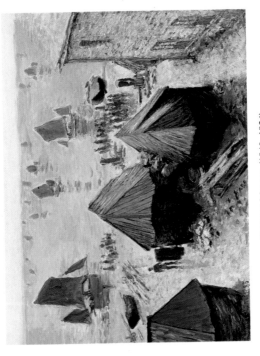

CLAUDE MONET (1840–1926)
Etretat: Departure of the Boats, 1885
Oil on canvas, 18⅞ x 36⅝ in. (46 x 93 cm)

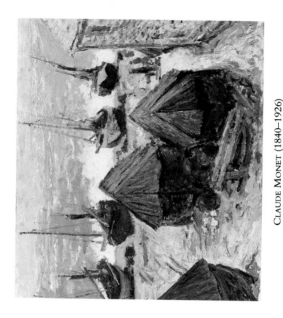

CLAUDE MONET (1840–1926)
Etretat: Boats in Winter Quarters, 1885
Oil on canvas, 25¾ x 32 in. (65.4 x 81.3 cm)

EDGAR DEGAS (1834–1917)
Mary Cassatt and Her Sister at the Louvre, 1885
102 Etching, aquatint, and pastel on paper, 12 x 5 in. (30.5 x 12.7 cm)

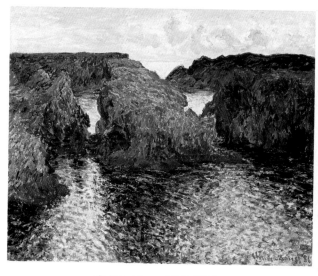

CLAUDE MONET (1840–1926)
Rocks at Belle Isle, 1886
Oil on canvas, 26 x 32¼ in. (66 x 82 cm)

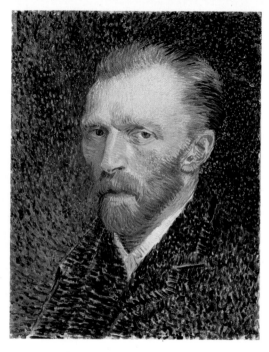

VINCENT VAN GOGH (1853–1890)
Self-Portrait, 1886/87
Oil on board, 16⅛ x 13¼ in. (41 x 33.7 cm)

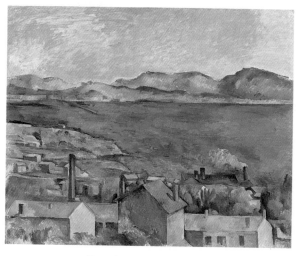

PAUL CÉZANNE (1839–1906)
The Bay of Marseilles, Seen from L'Estaque, 1886/90
Oil on canvas, 31½ x 39⅝ in. (80 x 99 cm)

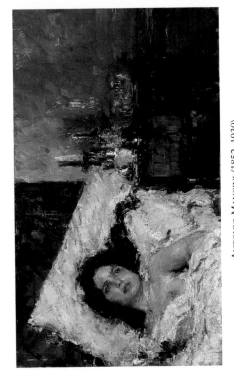

ANTONIO MANCINI (1852–1930)
Resting, c. 1887
Oil on canvas, 23⅝ x 39⅜ in. (60 x 100 cm)

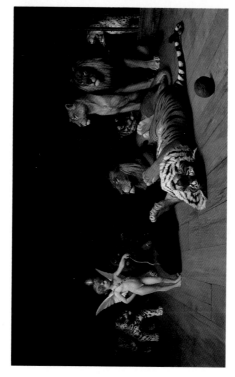

JEAN-LÉON GÉRÔME (1824–1904)
Love the Conqueror, 1889
Oil on canvas, 39¼ x 63⅛ in. (99.7 x 160.3 cm)

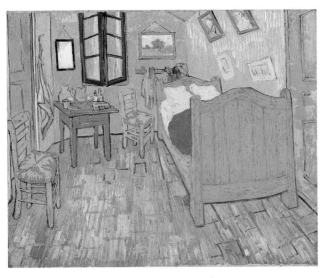

VINCENT VAN GOGH (1853–1890)
The Bedroom, 1888
Oil on canvas, 29 x 36⅝ in. (73.7 x 93 cm)

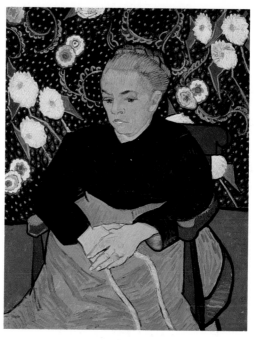

VINCENT VAN GOGH (1853–1890)
Madame Roulin Rocking the Cradle (La Berceuse), 1888
Oil on canvas, 36½ x 29½ in. (92.7 x 74.9 cm)

CLAUDE MONET (1840–1926)
The Petite Creuse, 1888–89
Oil on canvas, 25 7/8 x 36 5/8 in. (65.7 x 93 cm)

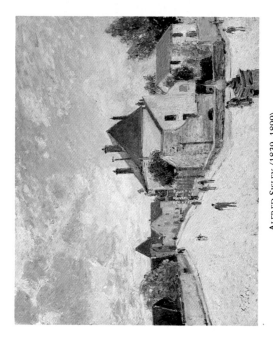

ALFRED SISLEY (1839–1899)
Street in Moret, c. 1890
Oil on canvas, 23⅞ x 28⅞ in. (60.6 x 73.3 cm)

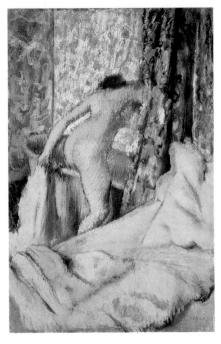

EDGAR DEGAS (1834–1917)
The Morning Bath, c. 1890
Pastel on paper, 27¾ x 17 in. (70.5 x 43.2 cm)

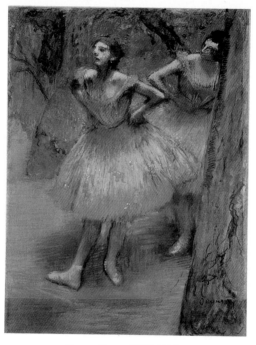

EDGAR DEGAS (1834–1917)
Two Dancers, c. 1890
Pastel on paper, 28 x 21⅜ in. (71.1 x 54.3 cm)

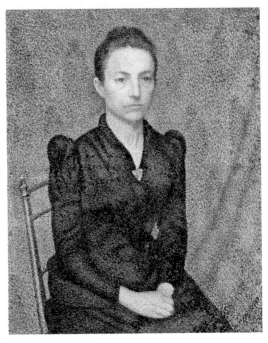

GEORGES LEMMEN (1865–1916)
Portrait of His Sister, 1891
Oil on canvas, 24½ x 20⅛ in. (62.2 x 51 cm)

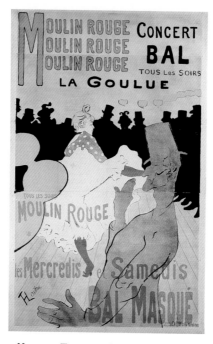

HENRI DE TOULOUSE-LAUTREC (1864–1901)
Moulin Rouge (La Goulue), 1891
Lithograph on paper, 75¼ x 46 in. (191 x 116.8 cm)

CLAUDE MONET (1840–1926)
Grainstacks (Sunset, Snow Effect), 1891
Oil on canvas, 25¾ x 39½ in. (65.4 x 100.3 cm)

Claude Monet (1840–1926)
Grainstack, 1891
Oil on canvas, 25⅞ x 36¼ in. (65.7 x 92 cm)

HENRI CROSS (1856–1910)
Beach at Cabasson, 1891/92
Oil on canvas, 25¼ x 36⅜ in. (65.4 x 92.4 cm)

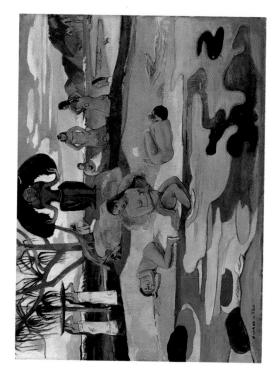

PAUL GAUGUIN (1848–1903)
Day of the Gods (Mahana no Atua), 1894
Oil on canvas, 26⅞ x 36 in. (68.3 x 91.4 cm)

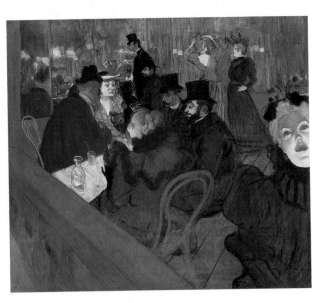

HENRI DE TOULOUSE-LAUTREC (1864–1901)
At the Moulin Rouge, 1892/95. Oil on canvas,
48½ x 55½ in. (123.2 x 141 cm)

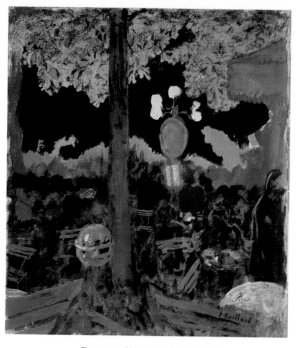

EDOUARD VUILLARD (1868–1940)
Evening in the Garden of the Alcazar, c. 1892/95
Distemper and pastel on paper, 19 x 17⅛ in. (48.3 x 43.5 cm) 121

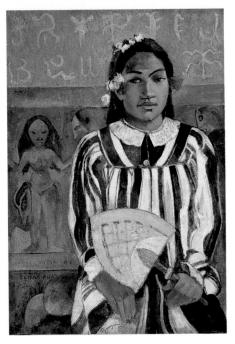

PAUL GAUGUIN (1848–1903)
Ancestors of Tehamana, 1893
Oil on canvas, 30⅛ x 21⅜ in. (76.5 x 54.3 cm)

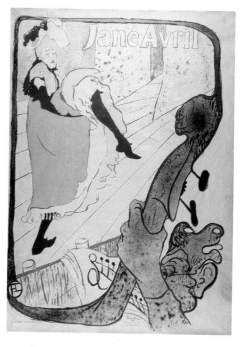

Henri de Toulouse-Lautrec (1864–1901)
Jane Avril, 1893
Lithograph on paper, 47½ x 34⅞ in. (120.7 x 88.6 cm)

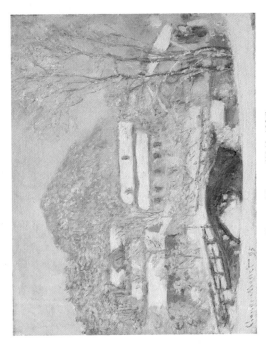

CLAUDE MONET (1840–1926)
Sandvika, Norway, 1895
Oil on canvas, 28⅞ x 36⅜ in. (73.3 x 92.4 cm)

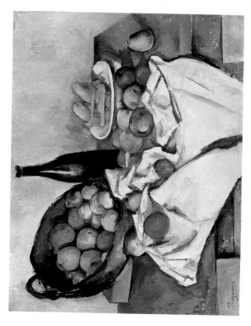

PAUL CÉZANNE (1839–1906)
Basket of Apples, c. 1895
Oil on canvas, 25½ x 31½ in. (64.8 x 80 cm)

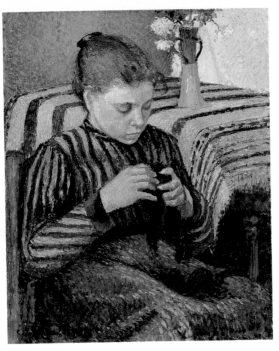

CAMILLE PISSARRO (1830–1903)
Girl Sewing, 1895
Oil on canvas, 25¾ x 21⅜ in. (65.4 x 54.3 cm)

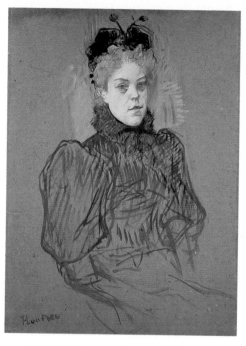

HENRI DE TOULOUSE-LAUTREC (1864–1901)
May Milton, 1895. Oil and pastel
on cardboard, 26 x 19⅜ in. (66 x 49.2 cm)

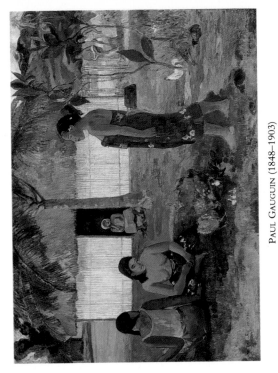

PAUL GAUGUIN (1848–1903)
Why Are You Angry? (No te aha oe riri), 1896
Oil on canvas, 37½ x 51⅛ in. (95.3 x 130.5 cm)

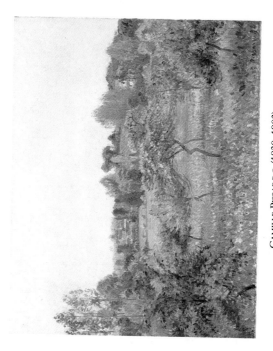

CAMILLE PISSARRO (1830–1903)
Eragny, A Rainy Day in June, 1898
Oil on canvas, 26¼ x 32½ in. (66.7 x 82.6 cm)

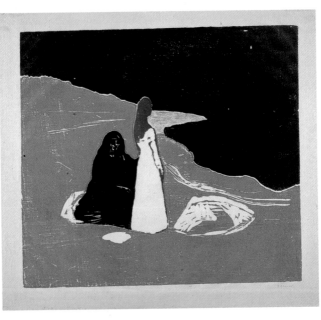

EDVARD MUNCH (1863–1944)
Women by the Shore, 1898

Woodcut on paper, 21 x 23⅜ in. (53.3 x 59.4 cm)

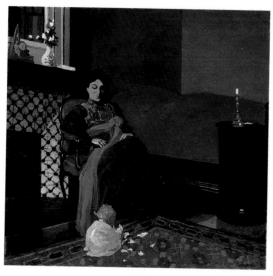

FÉLIX VALLOTTON (1865–1925)
Mme. Vallotton and Her Niece, Germaine Aghion, c. 1899/1900
Oil on cardboard, 19⅜ x 20⅜ in. (49.2 x 51.8 cm)

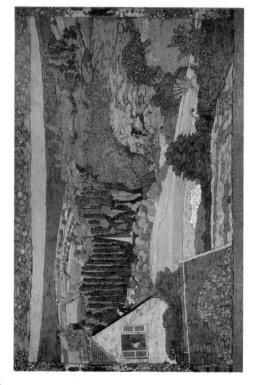

EDOUARD VUILLARD (1868–1940)
Landscape: Window Overlooking the Woods, 1899
Oil on canvas, 96⅛ x 149 in. (244.2 x 378.5 cm)

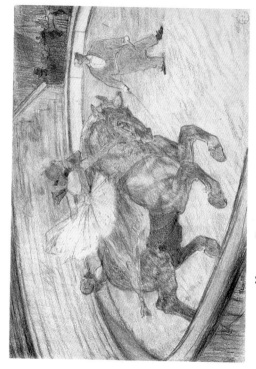

HENRI DE TOULOUSE-LAUTREC (1864–1901)
At the Circus, Work in the Ring, 1899. Colored pencils, pastels,
and crayon on paper, 8⅝ x 12½ in (21.9 x 31.8 cm)

NINETEENTH-CENTURY
AMERICAN PAINTING

The story of nineteenth-century North American art traces the struggle faced by this nation's artists trying at once to emulate the achievements of a European heritage and at the same time seeking to express a unique, American character and identity. It was not until the following century, with the mass immigration of European painters to the United States at the outbreak of World War II, that American artists arrived at a resolution to this conflict, developing Abstract Expressionism. In the pre-Civil War era, artists such as John Quidor (page 137), Eastman Johnson (page 148), and Susan Merritt (page 141) illustrated indigenous literature, documented communal rituals, and celebrated daily life. The Hudson River School artists, including Thomas Cole (page 138), Frederic Edwin Church (page 140), Jasper Francis Cropsey (page 145), and John Frederick Kensett (page 146), painted romantic visions of the beauty and grandeur they perceived in the "New World," exploring the vitality and splendor of life and land in the western hemisphere.

In the second half of the century, some artists, attracted by the sophistication of continental culture and the ground-breaking artistic developments taking place in Europe, chose to study and live extensively abroad.

Mary Cassatt (page 152), John Singer Sargent (page 174), and James McNeill Whistler (page 171) assumed rightful places in the forefront of contemporary European art. Other Americans who studied in Europe, among them Childe Hassam (page 164), George Inness (page 168), Maurice Prendergast (page 172), and John Henry Twachtman (page 162), brought their versions of Impressionism back to the States, applying the movement's brilliant color palette and broken brushwork to the American landscape. On the other hand, after periods of study or travel in Europe, artists such as Thomas Eakins (page 150) and Winslow Homer (page 144) evolved highly individual, insistently realistic styles to depict American urban and rural life.

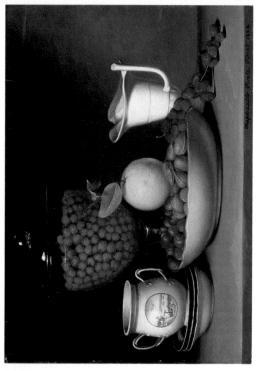

RAPHAELLE PEALE (1774–1825)
Still Life: Strawberries/Nuts/&c., 1824
Oil on panel, 16⅜ x 22¾ in. (41.6 x 57.8 cm)

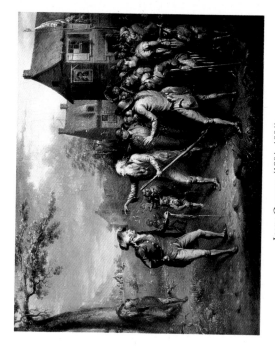

JOHN QUIDOR (1801–1881)
Rip van Winkle, 1829
Oil on canvas, 27½ x 34⅜ in. (69.9 x 87.3 cm)

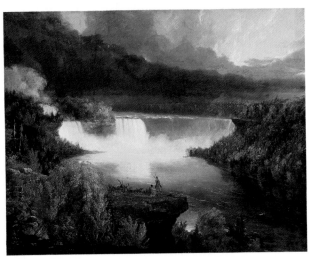

THOMAS COLE (1801–1848)
Niagara Falls, 1830
Oil on panel, 18⅞ x 23⅞ in. (47.9 x 60.6 cm)

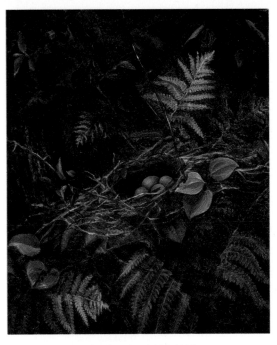

FIDELIA BRIDGES (1835–1923)
Bird's Nest and Ferns, 1863
Oil on panel, 8 x 6⅝ in. (20.3 x 16.8 cm)

FREDERIC EDWIN CHURCH (1826–1900)
Cotopaxi, 1857
Oil on canvas, 24½ x 36½ in. (62.2 x 92.7 cm)

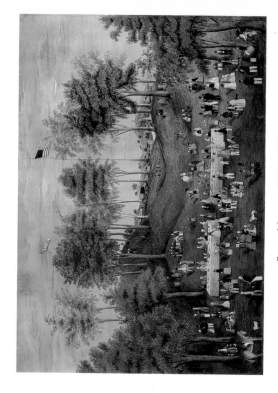

SUSAN MERRITT (1826–1879)
Picnic Scene, c. 1853. Watercolor and collage on paper, 26 x 36 in. (66 x 91.4 cm)

James McNeill Whistler (1834–1903)
Gray and Silver—Old Battersea Reach, 1863
Oil on canvas, 20 x 27 in. (51 x 68.6 cm)

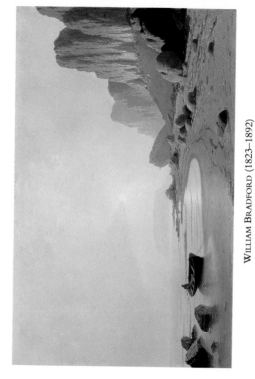

WILLIAM BRADFORD (1823–1892)
The Coast of Labrador, 1866
Oil on canvas, 28⅜ x 44⅝ in. (72 x 113.3 cm)

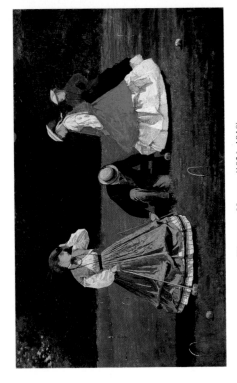

WINSLOW HOMER (1836–1910)
Croquet Scene, 1866
Oil on canvas, 15⅞ x 26⅛ in. (40.3 x 66.4 cm)

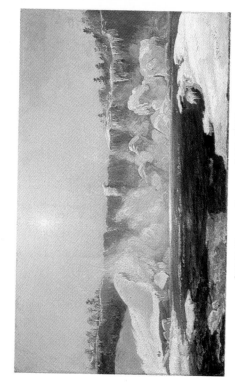

JASPER FRANCIS CROPSEY (1823–1900)
Niagara Falls in Winter, 1868
Oil on canvas, 12 x 20 in. (30.5 x 51 cm)

JOHN FREDERICK KENSETT (1816–1872)
Coast at Newport, 1869
Oil on canvas, 11⅝ x 24¼ in. (29.5 x 61.6 cm)

JAMES McNEILL WHISTLER (1834–1903)
Nocturne in Gray and Gold, 1872
Oil on canvas, 19⅞ x 29⅞ in. (50.5 x 75.9 cm)

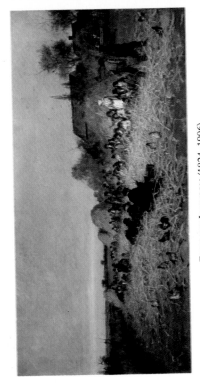

EASTMAN JOHNSON (1824–1906)
Husking Bee, Island of Nantucket, 1876
Oil on canvas, 27¼ x 54¼ in. (69.2 x 137.8 cm)

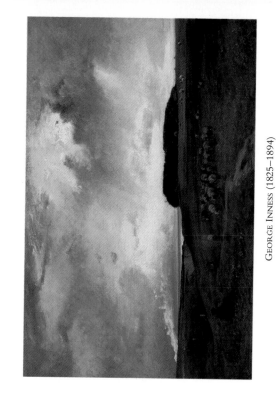

GEORGE INNESS (1825–1894)
The Storm, 1876
Oil on canvas, 25⅜ x 38¼ in. (64.5 x 97.2 cm)

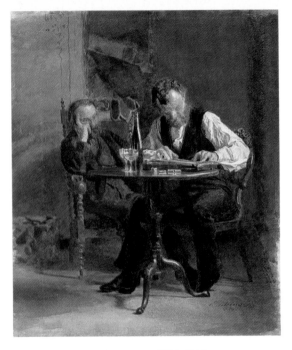

THOMAS EAKINS (1884–1916)
Zither Player, 1876
150 Watercolor over pencil on paper, 11⅜ x 9⅞ in. (28.9 x 25 cm)

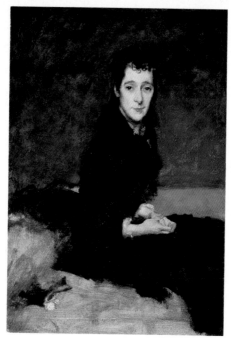

JOHN SINGER SARGENT (1856–1925)
Mrs. Charles Gifford Dyer, 1880
Oil on canvas, 24½ x 17¼ in. (62.2 x 44 cm)

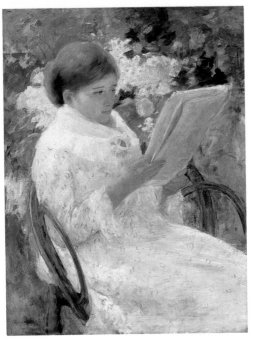

MARY CASSATT (1844–1926)
Woman Reading in a Garden, 1880
Oil on canvas, 35 ½ x 25 ⅝ in. (90.2 x 65.1 cm)

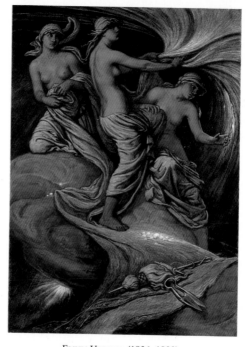

ELIHU VEDDER (1836–1923)
Fates Gathering in the Stars, 1887
Oil on canvas, 44½ x 32½ in. (113 x 82.6 cm)

John Singer Sargent (1856–1925)
Venetian Glass Workers, 1880/82
Oil on canvas, 22¼ x 33⅓ in. (56.5 x 84.5 cm)

Winslow Homer (1836–1910)
The Herring Net, 1885
Oil on canvas, 30⅛ x 48⅜ in. (76.5 x 123 cm)

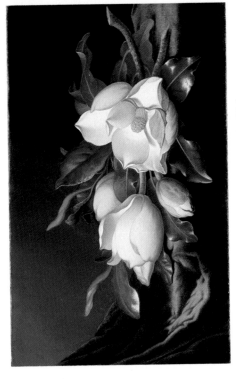

MARTIN JOHNSON HEADE (1819–1904)
Magnolias, 1885/90
Oil on canvas, 15¼ x 24⅛ in. (38.7 x 62 cm)

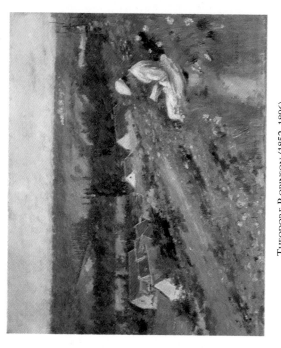

THEODORE ROBINSON (1852–1896)
The Valley of Arconville, 1887/89
Oil on canvas, 18 x 21⅞ in. (45.7 x 55.6 cm)

Winslow Homer (1836–1910)
"For to Be a Farmer's Boy," 1887
Watercolor over pencil on paper, 14 x 20 in. (35.6 x 51 cm)

WILLIAM MERRITT CHASE (1849–1916)
The Park, c. 1888
Oil on canvas, 13⅝ x 19⅝ in. (34.6 x 50 cm)

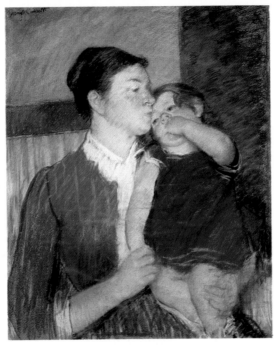

MARY CASSATT (1844–1926)
Mother and Child, 1888

Pastel on paper, 33⅛ x 29 in. (84 x 73.7 cm)

WILLIAM MICHAEL HARNETT (1848–1892)
For Sunday's Dinner, 1888
Oil on canvas, 37⅛ x 21⅛ in. (94.3 x 53.7 cm)

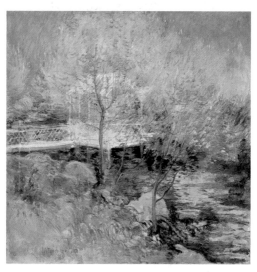

JOHN HENRY TWACHTMAN (1853–1902)
The White Bridge, 1889/1900
Oil on canvas, 30 x 30¼ in. (76.2 x 76.8 cm)

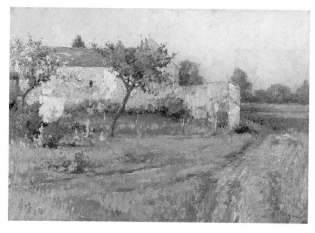

ROBERT VONNOH (1858–1933)
Spring in France, 1890
Oil on canvas, 15¼ x 22 in. (38.7 x 56 cm)

CHILDE HASSAM (1859–1935)
The Little Pond, Appledore, 1890
Oil on canvas, 16 x 22 in. (40.6 x 56 cm)

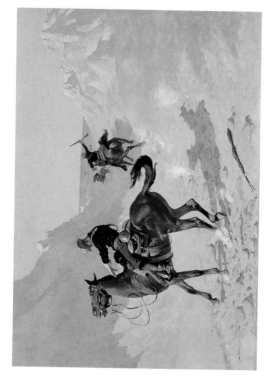

FREDERIC REMINGTON (1861–1909)
The Advance Guard, 1890
Oil on canvas, 34⅜ x 48½ in. (87.3 x 123.2 cm)

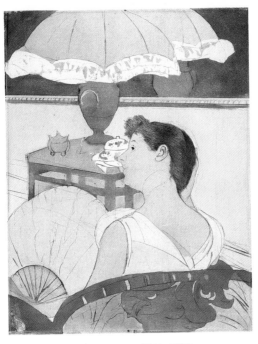

MARY CASSATT (1844–1926)
The Lamp, 1891. Drypoint, soft ground, and aquatint
on paper, 17 x 10½ in. (43.2 x 26.7 cm)

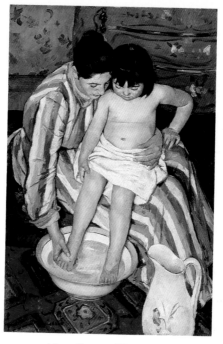

MARY CASSATT (1844–1926)
The Bath, 1891–92
Oil on canvas, 39½ x 26 in. (100 x 66 cm)

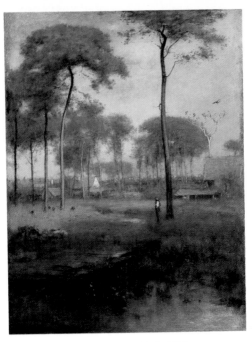

GEORGE INNESS (1825–1894)
Early Morning, Tarpon Springs, 1892
Oil on canvas, 42¼ x 32⅛ in. (107 x 82.2 cm)

JAMES McNEILL WHISTLER (1834–1903)
An Arrangement in Flesh Color and Brown—Arthur Jerome Eddy, 1894
Oil on canvas, 82½ x 36½ in. (210 x 92.7 cm) 169

George Inness (1825–1894)
Home of the Heron, 1893
Oil on canvas, 30 x 45½ in. (76.2 x 116 cm)

JAMES McNEILL WHISTLER (1834–1903)
Violet and Silver—The Deep Sea, 1893
Oil on canvas, 19¾ x 28⅞ in. (50.2 x 73.3 cm)

MAURICE BRAZIL PRENDERGAST (1859–1924)
South Boston Pier, 1895/98. Watercolor over pencil
on paper, 12¼ x 19½ in. (31.1 x 49 cm)

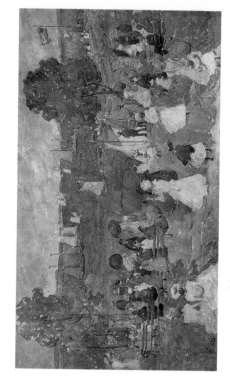

MAURICE BRAZIL PRENDERGAST (1859–1924)
Yacht Race, c. 1896–97. Watercolor over pencil
on paper, 14 x 20⅞ in. (35.6 x 53 cm)

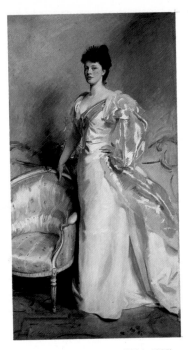

JOHN SINGER SARGENT (1856–1925)
Mrs. George Swinton, 1897
Oil on canvas, 90¾ x 48¾ in. (231 x 124 cm)

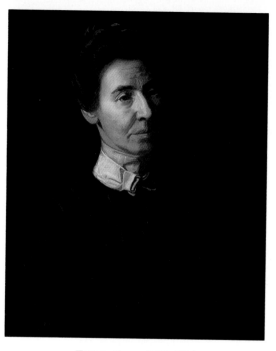

THOMAS EAKINS (1884–1916)
Mary Adeline Williams, 1899
Oil on canvas, 24 x 20⅛ in. (61 x 51.1 cm)

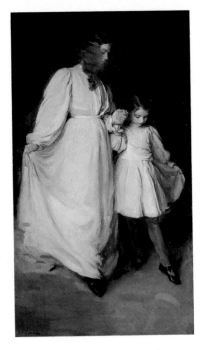

CECILIA BEAUX (1855–1942)
Dorothea and Francesca, 1898
Oil on canvas, 80⅛ x 46 in. (204 x 117 cm)

CHILDE HASSAM (1859–1935)
New England Headlands, 1899
Oil on canvas, 27⅛ x 27⅛ in. (69 x 69 cm)

TWENTIETH-CENTURY EUROPEAN PAINTING

The turn of this century inspired many artists to make a conscious break with the past. Liberated from having to mirror nature and claiming the right to re-create their surroundings according to formal, emotional, or spiritual considerations, they eagerly embraced experimentation. An epoch dominated by immense technological change and devastating world wars could not be satisfactorily reflected by artistic continuity. The first half of the century witnessed an astounding proliferation of successive "isms," foremost among them Cubism, Expressionism, and Surrealism. While some artists—Paul Klee (page 245), Fernand Léger (page 223), Joan Miró (page 237), Amedeo Modigliani (page 221), Piet Mondrian (page 239), and Georges Rouault (page 234) among them—chose to work in a consistently evolving style, others, most especially Pablo Picasso, experimented with a number of approaches. From the somber and expressive hues of his "blue period" (page 186) and the monochromatic, fragmented compositions of his Cubist period (page 201), to the stark, noble figures of his "classical period" (page 226), Picasso exemplifies the prototypical twentieth-century European painter, constantly reinventing himself and his art.

The Art Institute's collection of twentieth-century European art is an encyclopedic one, with special strengths in the work of Henri Matisse (page 198) and Picasso, and in Cubism and Surrealism. The museum contains outstanding examples of every important movement and nearly every major artist of the epoch. Recent acquisitions of works such as Anselm Kiefer's biblically inspired, mixed-media *The Order of the Angels* (page 259) and one of Lucian Freud's figurative explorations, *Two Japanese Wrestlers by a Sink* (page 258), demonstrate the variety of painting styles flourishing today.

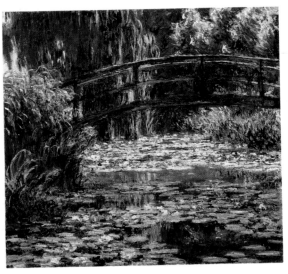

CLAUDE MONET (1840–1926)
Water Lily Pool, 1900
Oil on canvas, 35⅜ x 39¾ in. (90 x 101 cm)

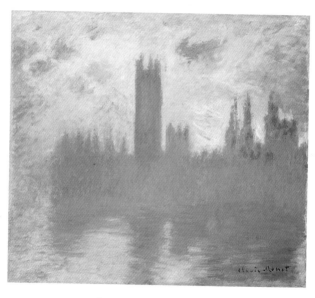

CLAUDE MONET (1840–1926)
Houses of Parliament, London, 1900/01
Oil on canvas, 31⅞ x 36¼ in. (81 x 92 cm)

CLAUDE MONET (1840–1926)
Waterloo Bridge, Gray Weather, 1900
Oil on canvas, 25¾ x 36⅜ in. (65.4 x 92.4 cm)

EDOUARD VUILLARD (1868–1940)
Child in a Room, c. 1900
Oil on cardboard, 17¼ x 22¾ in. (44 x 58 cm)

PAUL CÉZANNE (1839–1906)
Man Wearing a Straw Hat, 1900/06. Watercolor over pencil
on paper, 18¾ x 12⅜ in. (47.6 x 31.4 cm)

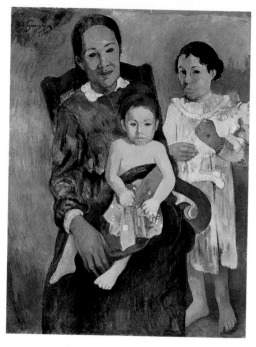

PAUL GAUGUIN (1848–1903)
Tahitian Woman with Children, 1901
Oil on canvas, 38⅜ x 29¼ in. (97.5 x 74.3 cm)

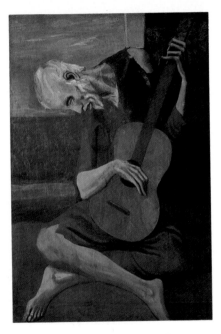

PABLO PICASSO (1881–1973)
The Old Guitarist, 1903
Oil on panel, 48⅛ x 32½ in. (122.9 x 82.6 cm)

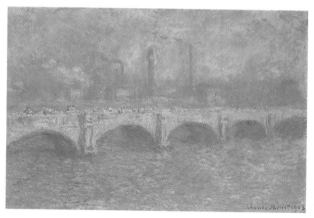

CLAUDE MONET (1840–1926)
Waterloo Bridge, Sunlight Effect, 1903
Oil on canvas, 25¾ x 39⅜ in. (65.4 x 100 cm)

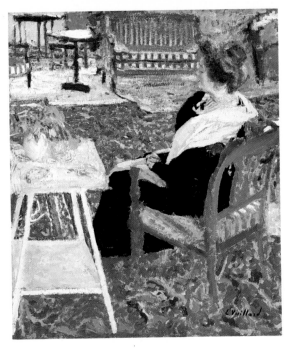

EDOUARD VUILLARD (1868–1940)
Madame Arthur Fontaine in a Pink Shawl, c. 1904/05
188 Gouache and oil on cardboard, 17 ⅜ x 15 in. (44 x 38.1 cm)

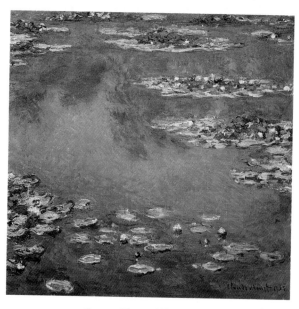

CLAUDE MONET (1840–1926)
Water Lilies, 1906
Oil on canvas, 35 ¼ x 36 ¾ in. (89.5 x 93.3 cm)

ERNST LUDWIG KIRCHNER (1880–1938)
Two Nudes, 1905
Chalk on paper, 24½ x 35⅛ in. (62.2 x 89.2 cm)

MAURICE DE VLAMINCK (1876–1958)
Houses at Chatou, c. 1905
Oil on canvas, 32 x 39⅝ in. (81.3 x 101 cm)

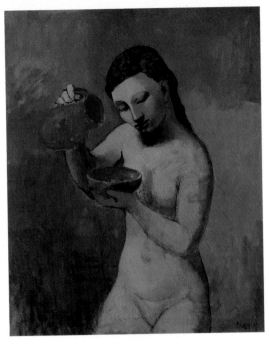

PABLO PICASSO (1881–1973)
Nude with a Pitcher, 1906
Oil on canvas, 39⅜ x 32 in. (100 x 81.3 cm)

FERDINAND HODLER (1853–1918)
James Vibert, Sculptor, 1907
Oil on canvas, 25 x 25 in. (63.5 x 63.5 cm)

GEORGES BRAQUE (1882–1963)
Landscape at La Ciotat, 1907
Oil on canvas, 23¾ x 28⅝ in. (60.3 x 73 cm)

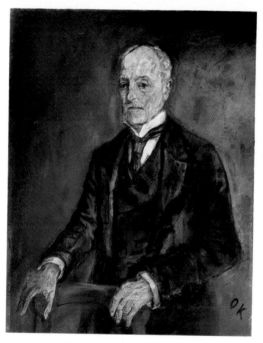

OSKAR KOKOSCHKA (1886–1980)
Commerce Counselor Ebenstein, 1908
Oil on canvas, 39 x 31 in. (99.1 x 78.7 cm)

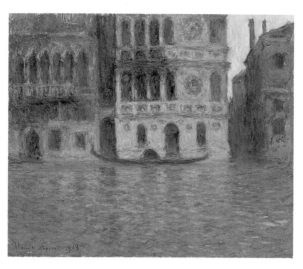

CLAUDE MONET (1840–1926)
Venice, Palazzo Dario, 1908
Oil on canvas, 25½ x 31 in. (65 x 78.7 cm)

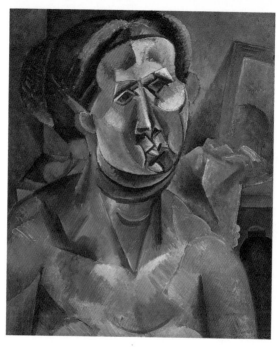

PABLO PICASSO (1881–1973)
Fernande Olivier, 1909
Oil on canvas, 23⅞ x 20¼ in. (60.6 x 51.4 cm)

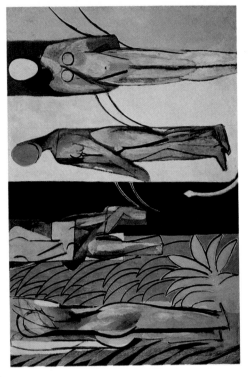

HENRI MATISSE (1869–1954)
Bathers by a River, 1909/16
Oil on canvas, 103 x 154 in. (262 x 391 cm)

HENRI ROUSSEAU (1844–1910)
The Waterfall, 1910
Oil on canvas, 45⅝ x 59 in. (116 x 150 cm)

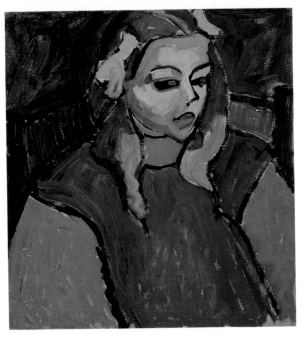

ALEXEJ JAWLENSKY (1864–1941)
Girl with the Green Face, 1910
Oil on board, 20⅞ x 19⅝ in. (53 x 50 cm)

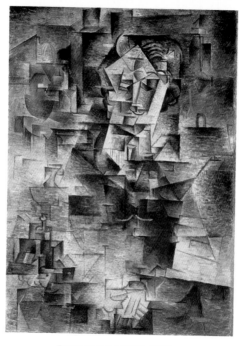

PABLO PICASSO (1881–1973)
Daniel-Henry Kahnweiler, 1910
Oil on canvas, 39⅝ x 28⅝ in. (101 x 73 cm)

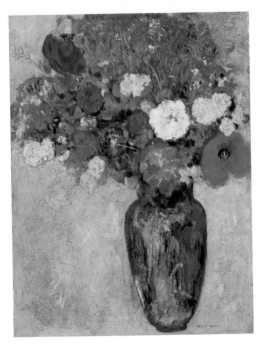

ODILON REDON (1840–1916)
Vase with Flowers, c. 1910
Oil on cardboard, 27 x 21 in. (69 x 53.3 cm)

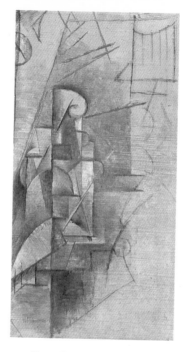

PABLO PICASSO (1881–1973)
The Glass, 1911–12
Oil on canvas and tape, 13 x 7 in. (33 x 18 cm)

VASILY KANDINSKY (1866–1944)
Painting with Troika, 1911. Oil on board,
27⅞ x 38¼ in. (70 x 97 cm)

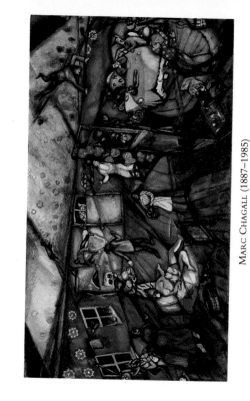

MARC CHAGALL (1887–1985)
Birth, 1911/12
Oil on canvas, 44¼ x 76⅛ in. (112 x 193 cm)

FRANCIS PICABIA (1879–1953)
Edtaonisl (Clergyman), 1913
Oil on canvas, 118¼ x 118⅜ in. (300 x 301 cm)

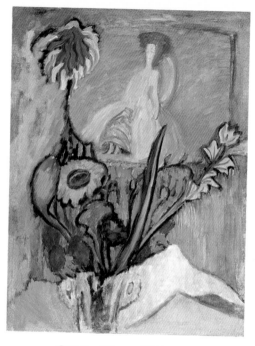

GABRIELE MÜNTER (1877–1962)
Still Life with Queen, 1912
Oil on canvas, 31 x 22⅛ in. (79 x 56.2 cm)

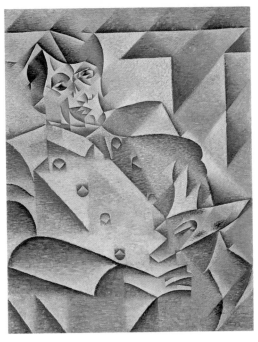

JUAN GRIS (1887–1927)
Portrait of Pablo Picasso, 1912
Oil on canvas, 29¼ x 26⅞ in. (74.3 x 68.3 cm)

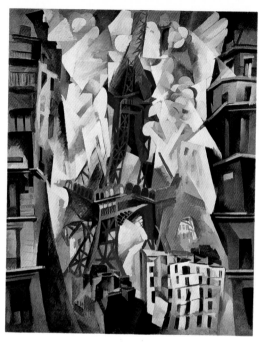

ROBERT DELAUNAY (1885–1941)
Champs de Mars: The Red Tower, 1911/23
Oil on canvas, 64 x 51½ in. (163 x 131 cm)

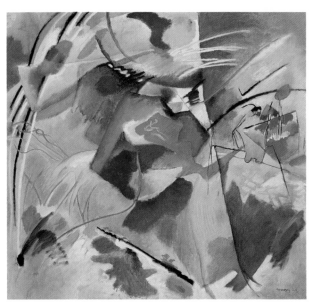

VASILY KANDINSKY (1866–1944)
Painting with Green Center, 1913
Oil on canvas, 43¼ x 47½ in. (110 x 121 cm)

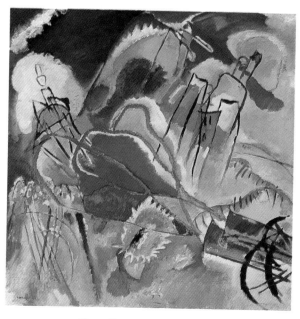

VASILY KANDINSKY (1866–1944)
Improvisation 30 (Cannons), 1913
Oil on canvas, 43⅝ x 43⅝ in. (111 x 111 cm)

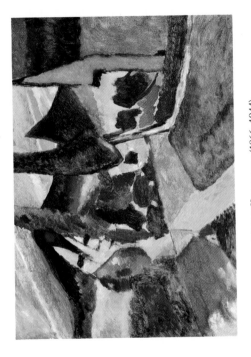

VASILY KANDINSKY (1866–1944)
Landscape with Two Poplars, 1912
Oil on canvas, 30⅞ x 39½ in. (78.4 x 100 cm)

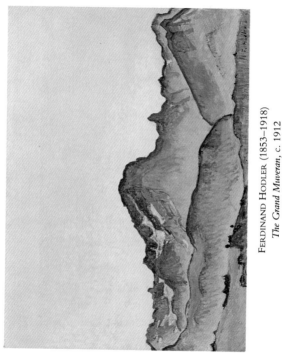

FERDINAND HODLER (1853–1918)
The Grand Muveran, c. 1912
Oil on canvas, 27¾ x 37½ in. (70.5 x 95 cm)

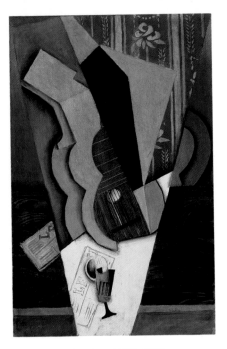

JUAN GRIS (1887–1927)
Guitar, Newspaper, and Glass, 1913
Oil on canvas, 36 x 23½ in. (91.4 x 59.7 cm)

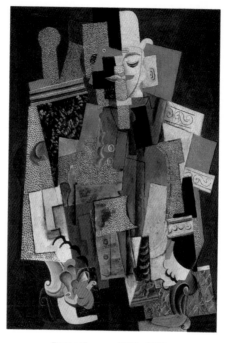

PABLO PICASSO (1881–1973)
Untitled (Man with Mustache, Buttoned Vest, and Pipe, Seated in an Armchair), 1915. Oil on canvas, 51¼ x 35¼ in. (130 x 90 cm) 215

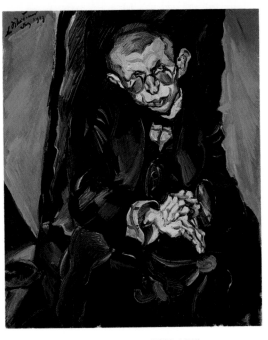

LUDWIG MEIDNER (1884–1966)
Portrait of Max Hermann-Neisse, 1913
Oil on canvas, 35¼ x 29¾ in. (90 x 76 cm)

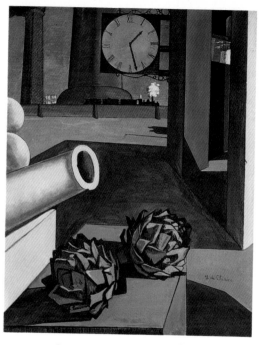

GIORGIO DE CHIRICO (1888–1978)
The Philosopher's Conquest, 1914
Oil on canvas, 49½ x 39¼ in. (126 x 100 cm)

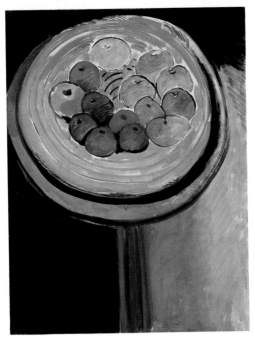

HENRI MATISSE (1869–1954)
Apples, 1916
Oil on canvas, 46 x 35 in. (117 x 89 cm)

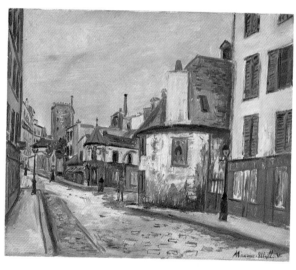

MAURICE UTRILLO (1883–1931)
The Tavern "La Belle Gabrielle," 1916
Oil on panel, 17½ x 21¼ in. (44.5 x 54 cm)

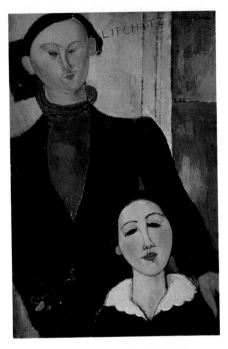

AMEDEO MODIGLIANI (1884–1920)
Jacques and Berthe Lipchitz, 1916
Oil on canvas, 31½ x 21 in. (80 x 53.3 cm)

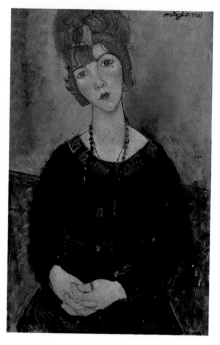

AMEDEO MODIGLIANI (1884–1920)
Woman with Necklace, 1917
Oil on canvas, 36 x 23⅞ in. (91.4 x 60.6 cm)

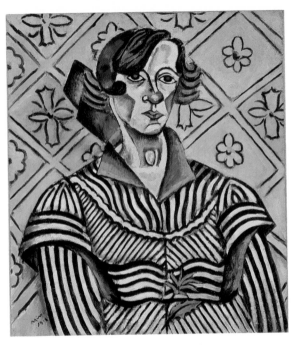

JOAN MIRÓ (1893–1983)
Portrait of a Woman, 1918
Oil on canvas, 27⅜ x 24⅜ in. (70 x 62 cm)

FERNAND LÉGER (1881–1955)
Sketch for *The Railway Crossing,* 1919
Oil on canvas, 25½ x 28⅛ in. (65 x 71.4 cm)

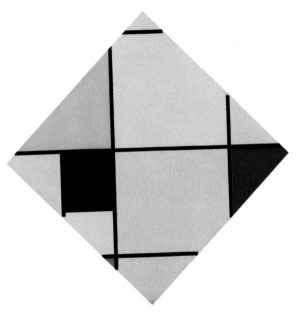

PIET MONDRIAN (1872–1944)
Diagonal Composition, 1921
Oil on canvas, 23⅝ x 23⅝ in. (60 x 60 cm)

HENRI MATISSE (1869–1954)
Woman before an Aquarium, 1921
Oil on canvas, 32 x 39½ in. (81.3 x 100 cm)

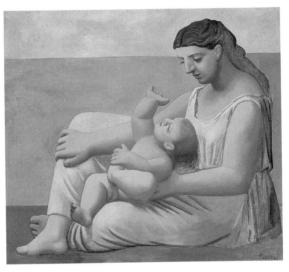

PABLO PICASSO (1881–1973)

Mother and Child, 1921

Oil on canvas, 56¼ x 68 in. (143 x 173 cm)

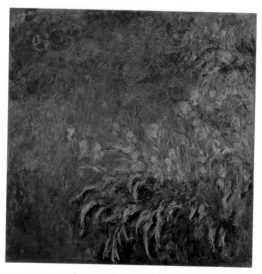

CLAUDE MONET (1840–1926)
Iris, c. 1922/26
Oil on canvas, 79 x 79½ in. (201 x 202 cm)

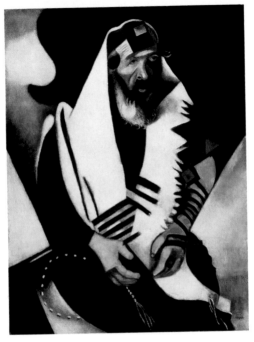

MARC CHAGALL (1887–1985)
The Praying Jew, 1923
Oil on canvas, 46 x 35 in. (117 x 89 cm)

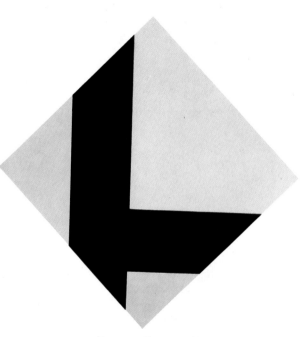

THEO VAN DOESBURG (1883–1931)
Counter-Composition VIII, 1924
Oil on canvas, 39⅜ x 39⅜ in. (100 x 101 cm)

CHAIM SOUTINE (1893–1943)
Dead Fowl, 1926
Oil on canvas, 38⅜ x 24⅞ in. (97.5 x 63.2 cm)

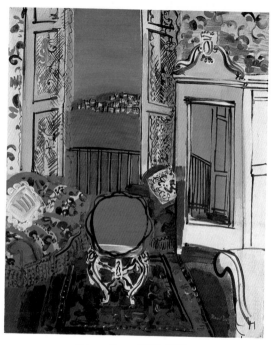

RAOUL DUFY (1877–1953)
Open Window, Nice, 1928
Oil on canvas, 25 ¾ x 21 ⅜ in. (65.4 x 54.3 cm)

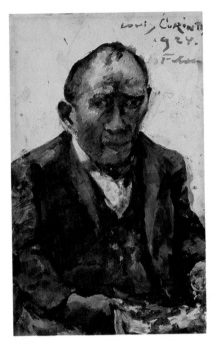

LOVIS CORINTH (1858–1925)
Self-Portrait, 1924
Gouache on paper, 19⅛ x 12 in. (49 x 30.5 cm)

JOAN MIRÓ (1893–1983)
The Policeman, 1925
Oil on canvas, 97⅝ x 76¾ in. (248 x 195 cm)

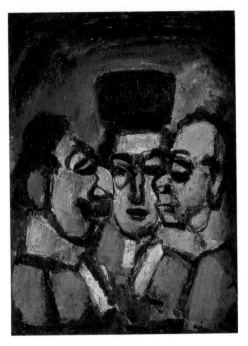

GEORGES ROUAULT (1871–1958)
The Three Judges, 1928. Oil and gouache
on canvas, 29⅛ x 21⅝ in. (74 x 55 cm)

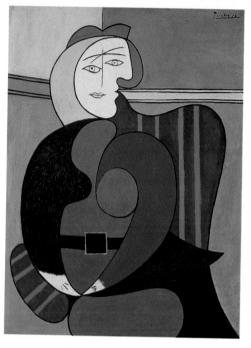

PABLO PICASSO (1881–1973)
The Red Armchair, 1931
Oil and enamel on panel, 51 ½ x 39 in. (131 x 99 cm)

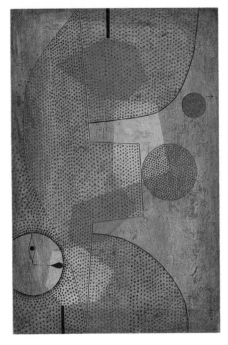

PAUL KLEE (1879–1940)
Sunset, 1930
Oil on canvas, 18⅛ x 27⅝ in. (46 x 70.2 cm)

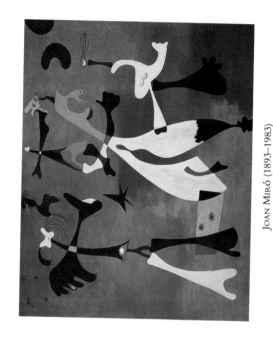

JOAN MIRÓ (1893–1983)
Personages with Stars, 1933
Oil on canvas, 77¼ x 97⅝ in. (196 x 248 cm)

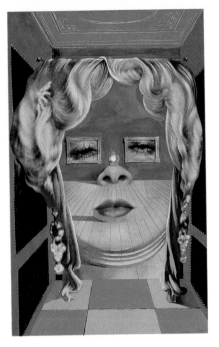

SALVADOR DALI (1904–1989)
Mae West, c. 1934. Gouache over
photographic print, 11⅛ x 7 in. (28.3 x 17.8 cm)

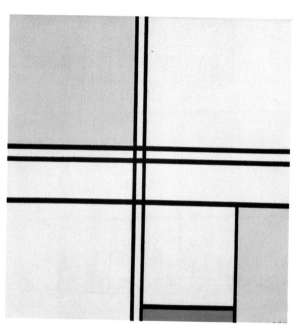

PIET MONDRIAN (1872–1944)
Composition in Red and Gray, 1935
Oil on canvas, 21⅝ x 22⅜ in. (55 x 57 cm)

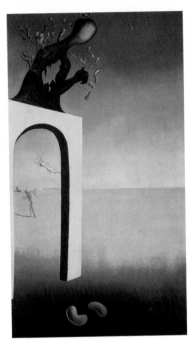

SALVADOR DALI (1904–1989)
Visions of Eternity, 1936/37
Oil on canvas, 81½ x 46¼ in. (207 x 117 cm)

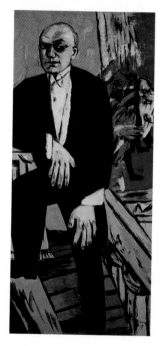

MAX BECKMANN (1884–1950)
Self-Portrait, 1937
Oil on canvas, 75¾ x 35 in. (192 x 89 cm)

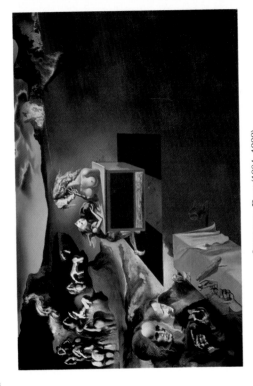

SALVADOR DALI (1904–1989)
Inventions of the Monsters, 1937
Oil on canvas, 20⅛ x 30⅞ in. (51.1 x 78.4 cm)

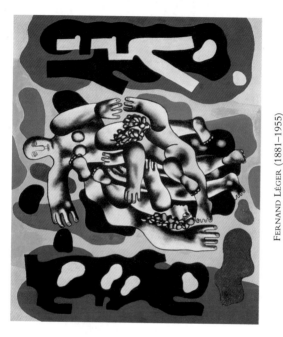

FERNAND LÉGER (1881–1955)
Divers on a Yellow Background, 1941
Oil on canvas, 75¾ x 87½ in. (192 x 222 cm)

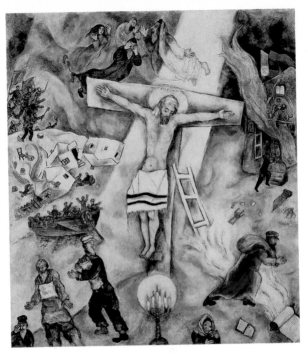

MARC CHAGALL (1887–1985)
White Crucifixion, 1938
Oil on canvas, 61 x 55 in. (155 x 140 cm)

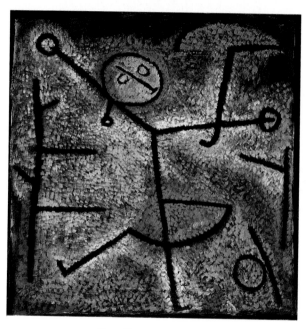

PAUL KLEE (1879–1940)
Dancing Girl, 1940. Oil on cloth
20⅛ x 20⅛ in. (51.1 x 51.1 cm)

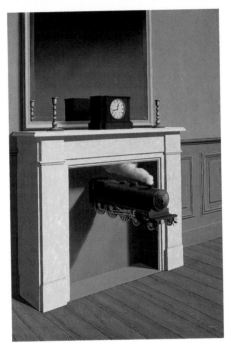

RENÉ MAGRITTE (1898–1967)
Time Transfixed, 1938
Oil on canvas, 57½ x 38⅜ in. (146 x 97.5 cm)

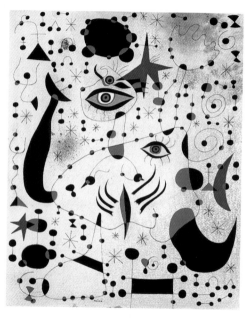

JOAN MIRÓ (1893–1983)
Symbols and Love Constellations of a Woman, 1941
Gouache on paper, 18 x 15 in. (46 x 38 cm)

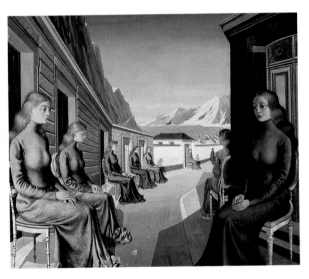

PAUL DELVAUX (b. 1897)
The Village of the Mermaids, 1942
Oil on panel, 41 x 49 in. (104 x 124 cm)

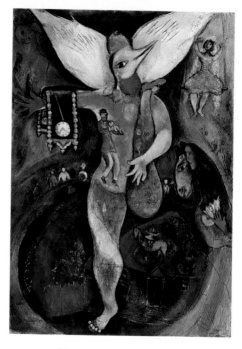

MARC CHAGALL (1887–1985)
Juggler, 1943
Oil on canvas, 43¼ x 31⅛ in. (110 x 79 cm)

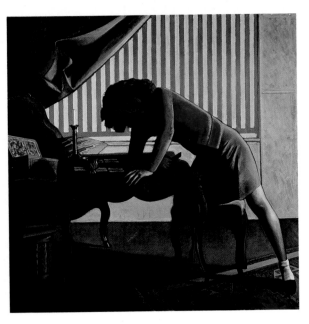

BALTHUS (b. 1908)
Solitaire, 1943
Oil on canvas, 63⅜ x 64½ in. (161 x 164 cm)

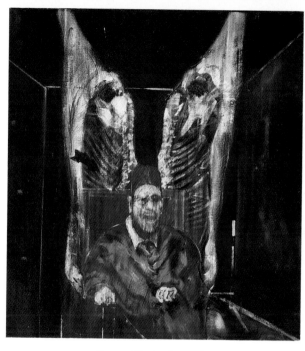

FRANCIS BACON (b. 1910)
Head Surrounded by Sides of Beef, 1954
Oil on canvas, 50⅞ x 48 in. (129 x 122 cm)

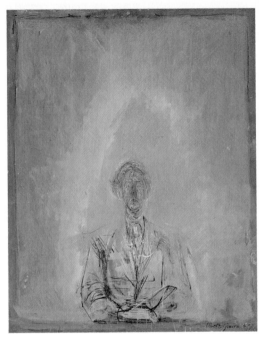

ALBERTO GIACOMETTI (1901–1966)
Isaku Yanaihara, 1956
Oil on canvas, 32 x 25⅝ in. (81.3 x 65 cm)

GERHARD RICHTER (b. 1932)
Christa and Wolfi, 1964
Oil on canvas, 59 x 51¼ in. (150 x 130.2 cm)

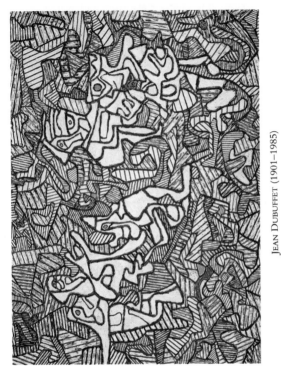

JEAN DUBUFFET (1901–1985)
Genuflection of the Bishop, 1963
Oil on canvas, 86¾ x 118 in. (220 x 300 cm)

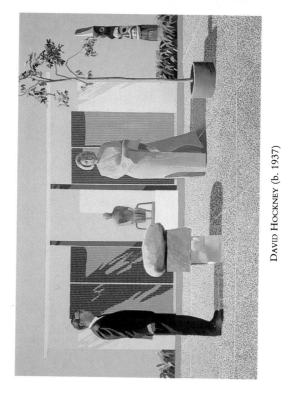

DAVID HOCKNEY (b. 1937)
American Collectors, 1968
Acrylic on canvas, 84 x 120 in. (213 x 305 cm)

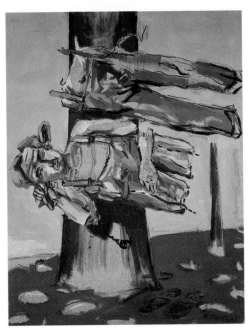

GEORG BASELITZ (b. 1938)
Woodman, 1969
Oil on canvas, 98½ x 78¾ in. (250 x 200 cm)

SIGMAR POLKE (b. 1941)
Raised Chair with Geese, 1987–88. Artificial resin and acrylic
on various fabrics, 118 x 88 in. (300 x 224 cm)

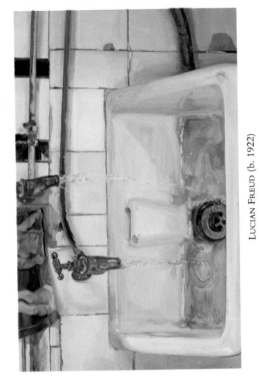

LUCIAN FREUD (b. 1922)
Two Japanese Wrestlers by a Sink, 1983–87
Oil on canvas, 20 x 31 in. (51 x 79 cm)

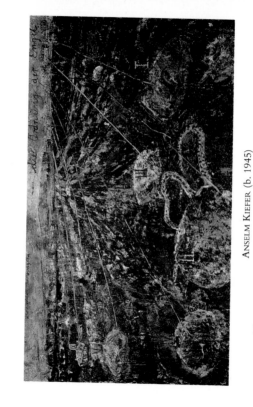

ANSELM KIEFER (b. 1945)
The Order of the Angels, 1983/84. Oil, emulsion, shellac, straw, and lead on canvas, 130 x 218½ in. (330 x 555 cm)

TWENTIETH-CENTURY
AMERICAN PAINTING

As the United States came into its own as a world power during this past century, so did its art. The 1913 Armory Show introduced Americans to dramatic developments in European art. Early on, American artists such as Lyonel Feininger (page 268) and Marsden Hartley (page 274) traveled to Europe and adopted the new styles to their own purposes. Others, including Charles Demuth (page 283), Edward Hopper (page 293), Jacob Lawrence (page 289), John Marin (page 271), Georgia O'Keeffe (page 278), and Grant Wood (page 280), insisted on retaining indigenous imagery, filtered through the new awareness of abstraction. Marin and O'Keeffe, in particular, experimented with abstract forms and compositions. In Mexico, José Clemente Orozco (page 281), Diego Rivera (page 273), and Rufino Tamayo (page 282) combined aspects of Cubism, Expressionism, and Surrealism with native forms and imagery to express and celebrate the rich and sometimes violent social history of their struggling nation.

The influx of many leading European artists seeking asylum in the United States from World War II greatly benefited a new generation of artists. Learning automatic

painting from the Surrealists, Willem de Kooning (page 298), Jackson Pollock (page 302), Mark Rothko (page 303), and others developed the first truly original American style: Abstract Expressionism. Living records of the painter's brushstrokes and movements, the works of the Abstract Expressionists refer not to an external subject, or to internal emotions, but rather to the very process of creation itself. Returning to recognizable imagery, Pop art, represented in the Art Institute by strong works by Roy Lichtenstein (page 313), Andy Warhol (page 317), and others, was inspired by consumer culture, taking its images from advertisements, comic books, and other popular ephemera. Continuing interest in the figure is seen in the work of many contemporary artists as well—testimony perhaps to the impact of tradition on painters today. Richard Estes's Photo-Realist canvases (page 318), Leon Golub's potent portrayals of human-rights atrocities (page 320), Philip Guston's cartoonish biographical works (page 319), and the media-inspired works of Chicago Imagist Ed Paschke (page 322) all highlight the complexity and richness of contemporary American culture.

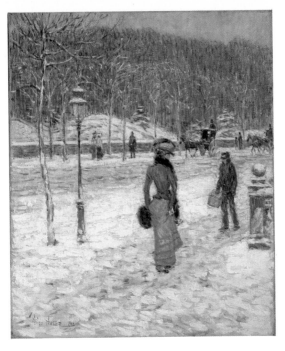

CHILDE HASSAM (1859–1935)
New York Street, 1902

Oil on canvas, 23½ x 19½ in. (59.7 x 49.5 cm)

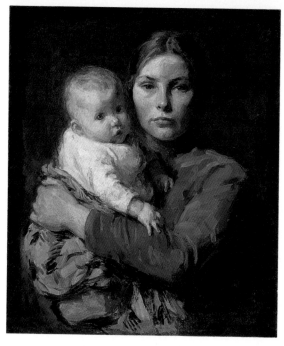

GARI MELCHERS (1860–1932)
Mother and Child, c. 1906
Oil on canvas, 25 x 21⅜ in. (63.5 x 54.3 cm)

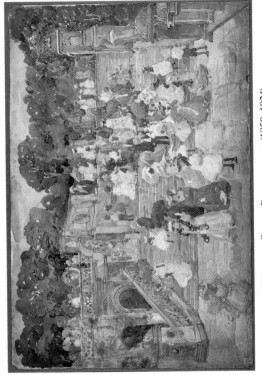

MAURICE BRAZIL PRENDERGAST (1859–1924)
The Mall, Central Park, 1901. Watercolor over graphite on paper, 15¼ x 22¼ in. (39 x 56.5 cm)

EVERETT SHINN (1876–1953)
The Hippodrome, London, 1902
Oil on canvas, 26⅜ x 35¼ in. (67 x 90 cm)

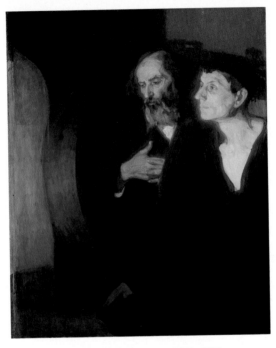

HENRY OSSAWA TANNER (1859–1937)
The Two Disciples at the Tomb, c. 1906
Oil on canvas, 51 x 41⅞ in. (130 x 106 cm)

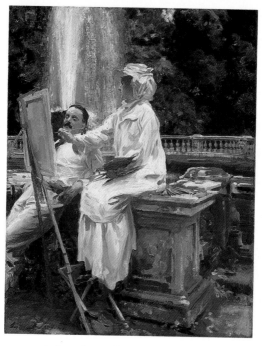

JOHN SINGER SARGENT (1856–1925)
The Fountain, Villa Torlonia, Frascati, 1907
Oil on canvas, 28⅛ x 22¼ in. (71.4 x 56.5 cm)

LYONEL FEININGER (1871–1956)
Carnival in Arcueil, 1911
Oil on canvas, 41¼ x 37¾ in. (105 x 96 cm)

ARTHUR DOVE (1880–1946)
Nature Symbolized No. 2, c. 1911
Pastel on paper, 18 x 21⅝ in. (46 x 55 cm)

GEORGE BELLOWS (1882–1925)
Love of Winter, 1914
Oil on canvas, 32 ⅛ x 40 in. (82 x 102 cm)

JOHN MARIN (1870–1953)
Movement, Fifth Avenue, 1912
Watercolor on paper, 16⅞ x 13⅝ in. (43 x 34.6 cm)

MARSDEN HARTLEY (1877–1943)
Movements, 1915
Oil on canvas, 47 ¼ x 47 ¼ in. (120 x 120 cm)

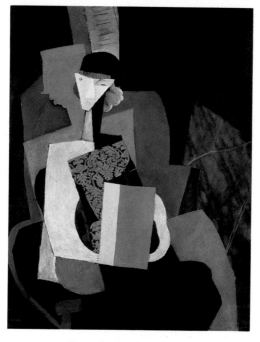

DIEGO RIVERA (1886–1956)
Portrait of Marevna Vorobëv-Stebelska, c. 1915
Oil on canvas, 57 ½ x 45 ½ in. (146 x 116 cm)

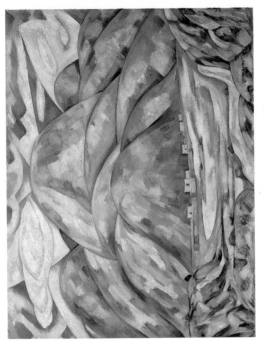

MARSDEN HARTLEY (1877–1943)
Landscape No. 3, 1920
Oil on canvas, 27¾ x 35¾ in. (70.5 x 91 cm)

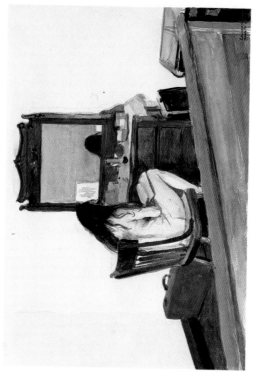

EDWARD HOPPER (1882–1967)
Interior, 1925. Watercolor over pencil
on paper, 13⅞ x 19⅞ in. (35.2 x 50.5 cm)

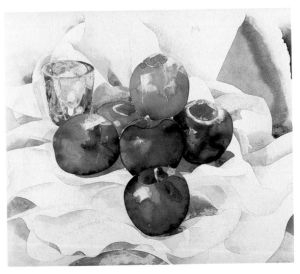

CHARLES DEMUTH (1883–1935)
Still Life: Apples, Green Glass, 1925. Watercolor over
pencil on paper, 11⅞ x 13¾ in. (30.2 x 35 cm)

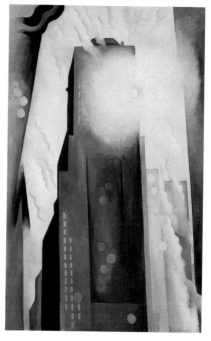

GEORGIA O'KEEFFE (1887–1986)
The Shelton with Sunspots, 1926
Oil on canvas, 48½ x 30¼ in. (123 x 77 cm)

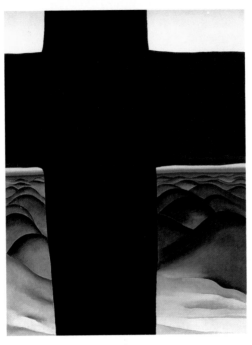

GEORGIA O'KEEFFE (1887–1986)
Black Cross, New Mexico, 1929
Oil on canvas, 39 x 30⅛ in. (99 x 76.5 cm)

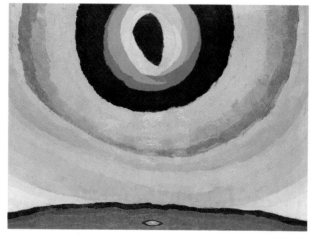

ARTHUR DOVE (1880–1946)
Silver Sun, 1929
Oil on canvas, 21⅝ x 29⅝ in. (55 x 75 cm)

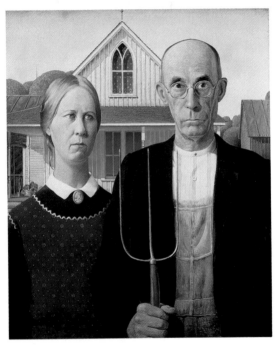

GRANT WOOD (1891–1942)
American Gothic, 1930
Oil on board, 29⅞ x 24⅞ in. (76 x 63.2 cm)

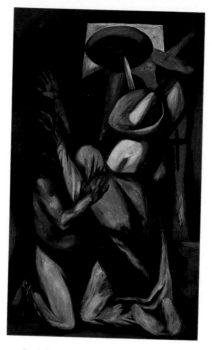

José Clemente Orozco (1883–1949)
Zapata, 1930
Oil on canvas, 78¼ x 48⅛ in. (199 x 123 cm)

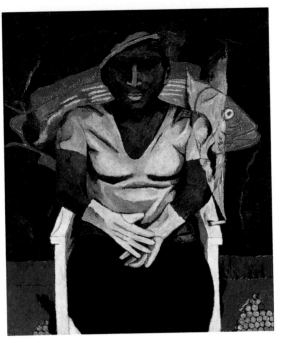

RUFINO TAMAYO (1899–1991)
Maria Izquierdo, c. 1930
Oil on canvas, 29 ½ x 25 ½ in. (75 x 65 cm)

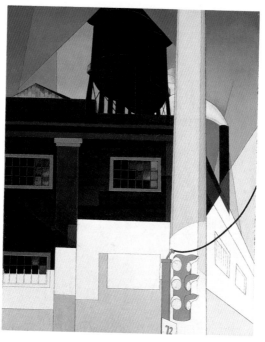

CHARLES DEMUTH (1883–1935)
And the Home of the Brave, 1931
Oil on board, 30 x 24 in. (76.2 x 61 cm)

IVAN ALBRIGHT (1897–1983)
That Which I Should Have Done I Did Not Do, 1931–41
Oil on canvas, 97 x 36 in. (246 x 91.4 cm)

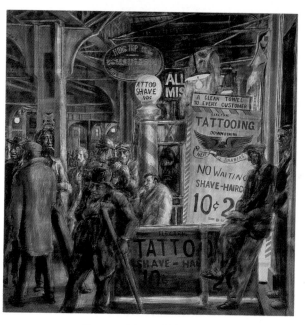

REGINALD MARSH (1898–1954)
Tattoo and Haircut, 1932
Tempera on masonite, 46½ x 47⅞ in. (118 x 122 cm)

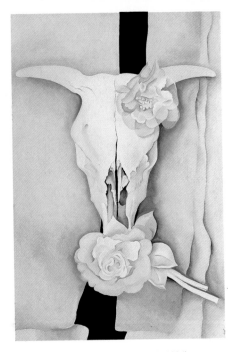

GEORGIA O'KEEFFE (1887–1986)
Cow's Skull with Calico Roses, 1932
Oil on canvas, 35⅞ x 24 in. (91 x 61 cm)

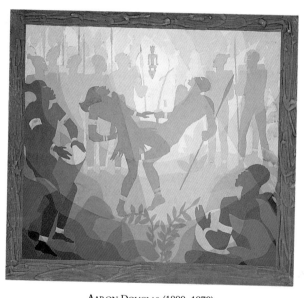

<small>AARON DOUGLAS (1899–1979)</small>
Study for *Aspects of Negro Life: The Negro in an African Setting*, 1934
Gouache on board, 16 x 15 in. (41 x 38 cm)

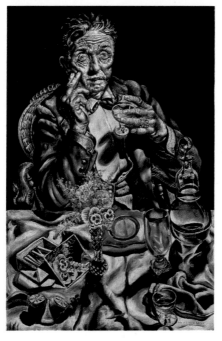

IVAN ALBRIGHT (1897–1983)
Self-Portrait, 1935
Oil on canvas, 30⅜ x 19⅞ in. (77 x 50.5 cm)

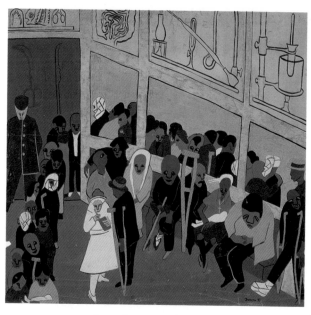

JACOB LAWRENCE (b. 1917)
Free Clinic, 1937
Gouache on paper, 30¼ x 32⅛ in. (77 x 82 cm)

DORIS LEE (1905–1983)
Thanksgiving, c. 1935
Oil on canvas, 28⅛ x 40 in. (71.4 x 102 cm)

WALTER W. ELLISON (1899–1977)
Train Station, 1936
Oil on canvas, 8 x 14 in. (20.3 x 35.6 cm)

HORACE PIPPIN (1888–1946)
Cabin in the Cotton, c. 1936
Oil on panel, 18 x 33 in. (46 x 84 cm)

292

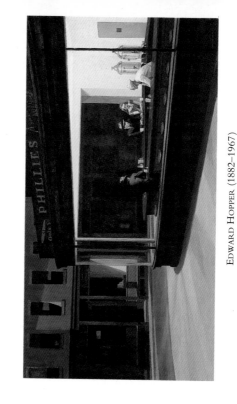

EDWARD HOPPER (1882–1967)
Nighthawks, 1942
Oil on canvas, 33⅛ x 60⅛ in. (84 x 153 cm)

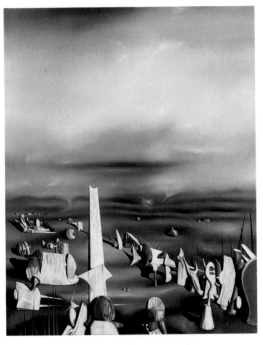

YVES TANGUY (1900–1955)
Rapidity of Sleep, 1945
Oil on canvas, 50 x 40 in. (127 x 102 cm)

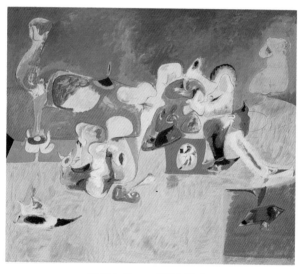

ARSHILE GORKY (1904–1948)
The Plow and the Song, 1946
Oil on canvas, 51⅞ x 61⅜ in. (132 x 156 cm)

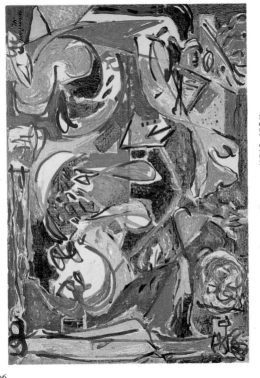

JACKSON POLLOCK (1912–1956)
The Key, 1946
Oil on canvas, 59 x 84 in. (150 x 213 cm)

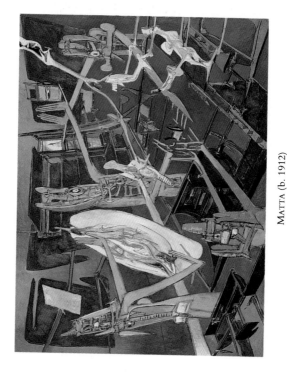

MATTA (b. 1912)
Wound Interrogation, 1948
Oil on canvas, 59 x 77 in. (150 x 196 cm)

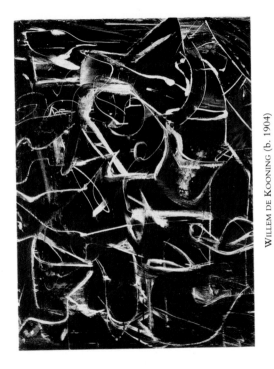

WILLEM DE KOONING (b. 1904)
Untitled, 1948–49. Oil and enamel on paper
mounted on board, 37⅜ x 50 in. (95 x 127 cm)

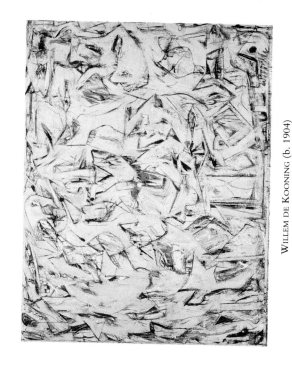

WILLEM DE KOONING (b. 1904)
Excavation, 1950
Oil on canvas, 80⅛ x 100⅛ in. (204 x 254 cm)

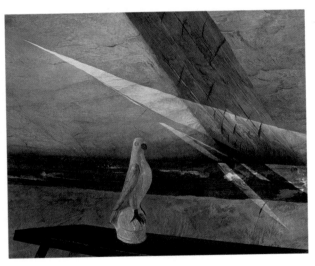

ANDREW WYETH (b. 1917)
The Cloister, 1949
Tempera on board, 32 x 41 in. (81.3 x 104 cm)

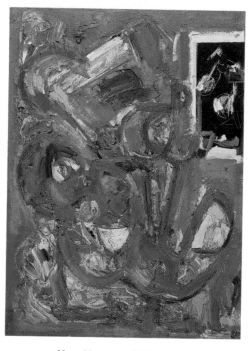

HANS HOFMANN (1880–1966)
Blue Rhythm, 1950
Oil on canvas, 48 x 36 in. (122 x 91.4 cm)

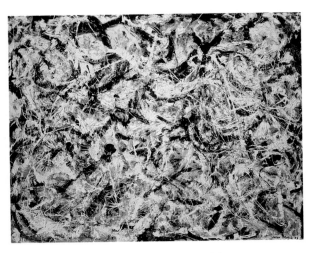

JACKSON POLLOCK (1912–1956)
Grayed Rainbow, 1953
Oil on canvas, 72 x 96 in. (183 x 244 cm)

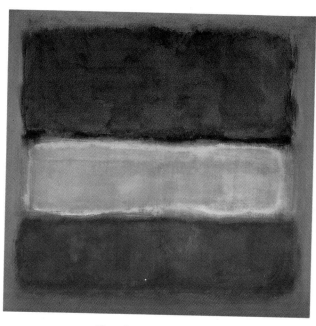

MARK ROTHKO (1903–1970)
Purple, White, and Red, 1953
Oil on canvas, 77¾ x 81¼ in. (197 x 208 cm)

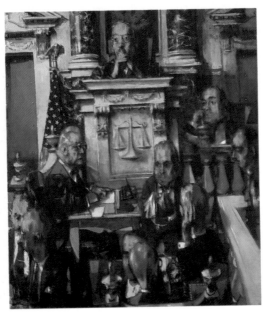

JACK LEVINE (b. 1915)
The Trial, 1953/54
Oil on canvas, 72 x 63 in. (183 x 160 cm)

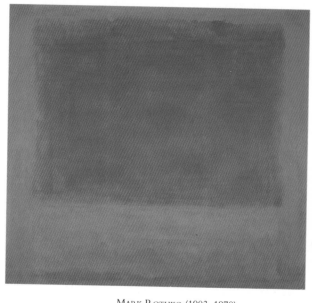

MARK ROTHKO (1903–1970)
Painting, 1954
Oil on canvas, 104½ x 117¼ in. (265 x 298 cm) 305

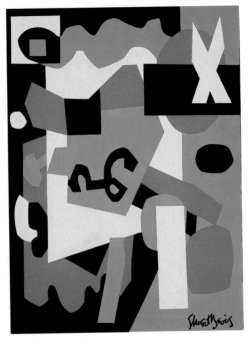

STUART DAVIS (1894–1964)
Ready to Wear, 1955
Oil on canvas, 56¼ x 42 in. (143 x 107 cm)

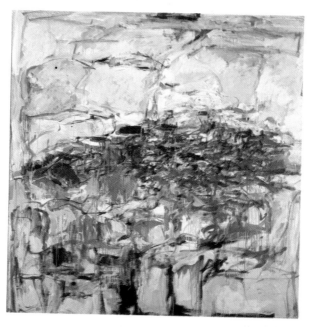

JOAN MITCHELL (1926–1992)
City Landscape, 1955
Oil on canvas, 80 x 80 in. (203 x 203 cm)

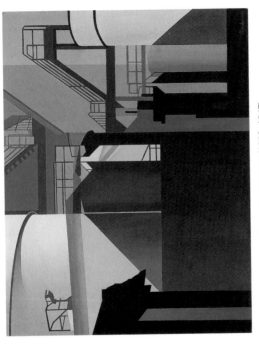

CHARLES SHEELER (1882–1967)
Western Industrial, 1955
Oil on canvas, 22⅞ x 29 in. (58 x 74 cm)

ROBERT RAUSCHENBERG (b. 1925)
Lincoln, 1958. Oil and collage
on canvas, 17 x 20⅞ in. (43.2 x 53 cm)

HANS HOFMANN (1880–1966)
The Golden Wall, 1961
Oil on canvas, 60 x 72½ in. (152 x 184 cm)

JULES OLITSKI (b. 1922)
Born in Snovsk, 1963
Acrylic on canvas, 132 x 90 in. (335 x 229 cm)

Morris Louis (1912–1962)
Earth, 1959
Acrylic on canvas, 92 x 138¾ in. (234 x 352 cm)

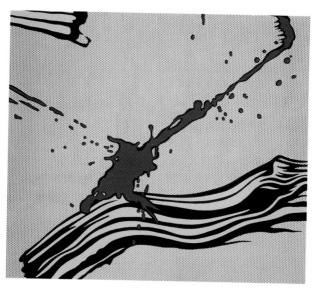

Roy Lichtenstein (b. 1923)
Brushstroke with Spatter, 1966
Oil and magna on canvas, 68 x 80 in. (173 x 203 cm)

313

GEORGIA O'KEEFFE (1887–1986)
Sky Above Clouds IV, 1965
Oil on canvas, 96 x 288 in. (244 x 732 cm)

ALEX KATZ (b. 1927)
Vincent and Tony, 1969
Oil on canvas, 72 x 120 in. (183 x 305 cm)

RICHARD DIEBENKORN (b. 1922)
Ocean Park No. 45, 1971
Oil on cotton duck, 100 x 81 in. (254 x 206 cm)

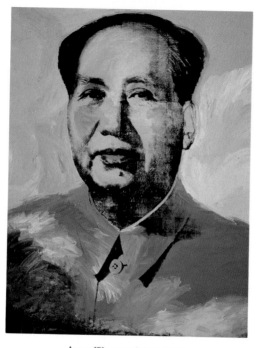

ANDY WARHOL (1930–1987)
Mao, 1973. Acrylic and silkscreen
on canvas, 176½ x 136½ in. (448 x 347 cm)

RICHARD ESTES (b. 1937)
Café Express, 1975
Oil on canvas, 24 x 36 in. (61 x 91.4 cm)

PHILIP GUSTON (1913–1980)
Green Sea, 1976
Oil on canvas, 70 x 116½ in. (178 x 296 cm)

LEON GOLUB (b. 1922)
Interrogation II, 1981
Acrylic on canvas, 120 x 168 in. (305 x 427 cm)

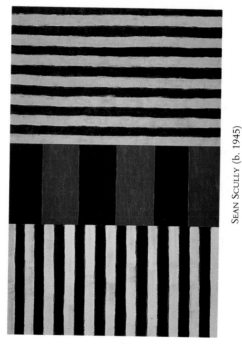

SEAN SCULLY (b. 1945)
Heart of Darkness, 1982
Oil on canvas, 96 x 144 in. (244 x 366 cm)

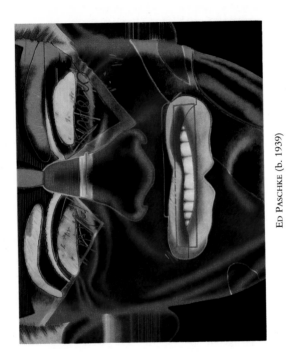

ED PASCHKE (b. 1939)
Caliente, 1985
Oil on canvas, 80 x 100 in. (203 x 254 cm)

ROBERT LOSTUTTER (b. 1939)
Baird Trogon, 1985. Watercolor over graphite
on paper, 24¼ x 34⅝ in. (62 x 88 cm)

JULIAN SCHNABEL (b. 1951)
The Wind, 1985. Spray enamel and modeling paste
on tarpaulin, 177 x 223 in. (450 x 566 cm)

INDEX OF DONORS' CREDITS

INDEX OF ILLUSTRATIONS

330